CRITICAL MESSAGES

RICK BARTOW

CRITICAL MESSAGES

CONTEMPORARY NORTHWEST ARTISTS ON THE ENVIRONMENT

ESSAYS BY SARAH CLARK-LANGAGER
AND WILLIAM DIETRICH

WESTERN GALLERY, WESTERN WASHINGTON UNIVERSITY, BELLINGHAM, WASHINGTON
HALLIE FORD MUSEUM OF ART, WILLAMETTE UNIVERSITY, SALEM, OREGON

This book was published in conjunction with the exhibition *Critical Messages: Contemporary Northwest Artists on the Environment*, organized by the Western Gallery, Western Washington University, Bellingham, Washington, in collaboration with the Hallie Ford Museum of Art, Willamette University, Salem, Oregon.

Exhibition curated by Sarah Clark-Langager.

Financial support for the exhibition and this accompanying publication was made possible, in part, by a grant from the National Endowment for the Arts, a federal agency. Additional support was provided by the Homer Bernard Mathes Endowment at the Western Gallery, an anonymous fund in Seattle, funds from the Western Washington University Foundation designated for the Western Gallery, the Hallie Ford Museum of Art Exhibition Fund, the City of Salem's Transient Occupancy Tax funds, and the Oregon Arts Commission.

Artworks on the covers:

Front cover, from top: John Grade, *Collector: Willapa Bay, Washington*, 2006–08; Matt Sellars, *Empty Quarter* (detail), 2008; Adam Sorenson, *Banks I* (detail), 2009.

Back cover, from top:
Susan Robb, *Using De Maria's Lighting Rod, The Animals Stage A Valiant Surrender*, 2008; Laura McPhee, *Understory Flareups, Fourth of July Creek, Valley Road Wildfire, Custer County, Idaho (River of No Return)*, 2005; Craig Langager, *Tille, All Primped and Ready for Wall Street* (detail), 2008; Chris Jordan, *Plastic Bottles* (detail), 2007.

Designed by Phil Kovacevich

Editorial review by Sigrid Asmus

Printed and bound in Canada

Photographer credits:

Bill Bachhuber, 18, 32, 33; Lele Barnett, 66, 67; Paul Brower, 54, 55, and back cover (third from top); Maria Grade, 47 (top); Nancy Hines, 60, 61; Aaron Johanson, 43; Kevin Kennefick, 28, 29; Dan Kvitka, 38, 39, 48, 49, 74, 75, and front cover (bottom image); Jerry McCollum, 50, 51; Frank Miller, 26, 27, 77; Richard Nicol, 17, 44, 45, 65, and back cover (top); Star Sutherland, 73; Steve Pitkin, 59; The Brand Studio, 8, 34, 35; and Mark Woods, 71 and front cover (middle image).

ITINERARY:

Western Gallery, Western Washington University
April 12–May 29, 2010

Hallie Ford Museum of Art, Willamette University
August 28–November 7, 2010

Boise Art Museum, Boise, Idaho
December 18, 2010–April 11, 2011

Library of Congress Control Number: 2010921412
ISBN: 978-1-878237-07-1

Distributed by
University of Washington Press
P.O. Box 50096
Seattle, Washington 98145-5096
www.washington.edu/uwpress

CONTENTS

ACKNOWLEDGMENTS

Critical Messages: Northwest Artists on the Environment represents the first critical examination of some of the key environmental issues that face our region, and is an exploration of the many ways contemporary Northwest artists are responding to those issues in their artwork. So often, contemporary artists are at the forefront of critical dialogues about social, political, and environmental issues and it is a pleasure to share their observations, interpretations, and artwork with audiences in Washington, Oregon, and Idaho. Key to the development of this exhibition have been several important and timely events: Philip Govedare's knock on the door of the Western Gallery in 2006 to propose some type of show on the environment; the partnership of the Western Gallery and the Hallie Ford Museum of Art on the eve of the 2008 National Endowment for the Arts grant deadline; and the acknowledgment by the NEA one year later that, indeed, we had been awarded a grant for our exhibition on Northwest artists responding to the environment.

During 2006 and 2007 various informal roundtables and quieter conversations on what this exhibition could and should be occurred at Western, University of Washington, Willamette University, and the Tacoma Art Museum. Knowledgeable participants joining in these conversations were Rock Hushka, Curator of Contemporary and Northwest Art at the Tacoma Art Museum, who over the years has provided in his own stellar exhibitions the social and artistic history of the region; Gary Handwerk, Professor of Comparative Litera-

ture at the University of Washington, who offered parallels in literature on the political, philosophical, and ethical strands of environmentalism; Stephanie Harrington, Assistant Dean of the College of the Environment at the University of Washington, who advocated for a strong educational component to the exhibition; and William Dietrich, Assistant Professor of Environmental Studies at Western, who knew the real issues. As the deadline loomed for the National Endowment for the Arts grant in 2008, Debra Jensen, an independent consultant specializing in grant writing, rose to the occasion and helped write a competitive and ultimately successful grant proposal. As we began to organize the exhibition, both Bill Dietrich and Brad Smith, Dean of Huxley College at Western, were crucial in sifting through the environmental conditions that are particularly relevant to the Northwest.

These issues form only a part of the mix of our twenty-six artists' conceptual and metaphorical investigations, interpretations, and re-imaginations of the world. After our pairing of their objects with our designated issues we gave them the opportunity to respond in their own words. It is clear that both their illuminating artworks and statements dominate over any unintentional categorization or pigeon-holing of their work. As organizers of a thematic exhibition hopefully enhancing public awareness, we are deeply appreciative of the artists' willingness to bend with our interpretations as well as lend their works. We also received generous guidance from galleries and their staff. In Seattle:

Sam Davidson, Davidson Galleries; Gail Gibson, G. Gibson Gallery; Linda Hodges, Linda Hodges Gallery; Jim Harris, James Harris Gallery; Stephen Lyons, Platform Gallery; and Francine Seders, Francine Seders Gallery. In Portland: Gina Carrington, Blackfish Gallery; Charles Froelick, Froelick Gallery; Laura Russo and Katrina Woltze, Laura Russo Gallery. In California: Kopeikin Gallery, Los Angeles, and Gallery Luisetti, Santa Monica. Both the Hallie Ford Museum of Art and the Boise Art Museum graciously allowed us to borrow important works from their rich collections of Northwest art. We also are indebted to our collectors who are passionate about Northwest art and have allowed some of their favorite works to be gone for such an extended period: John and Linda Anderson, Rockford, Illinois; Danielle Bodine, Clinton, Washington; Bill Driscoll and Lisa Hoffman, Tacoma, Washington; and Ron Kloepfer, Portland, Oregon.

We are honored that William Dietrich, a Pulitzer Prize–winning journalist, enthusiastically embraced the concept of our exhibition. Most importantly, his inspiring essay helps us to refine our thinking about where and how we live and to better understand the context of our artists' reflective works. This book was produced by the talented Phil Kovacevich in Seattle who responded to our exhibition with a sophisticated design highlighting both the artists and our core concepts. Sigrid Asmus was gracefully astute in editing our written materials.

As always, Gaye Green, Professor of Art Education at Western, has prepared a thorough education packet in CD format for K-12 schools. While aware of the Northwest's mandated educational goals directing curriculum, she is able to infuse the lessons with wit and imagination. The wide range of art forms, combined with Dietrich's insightful essay

and Green's creative approaches to education, will contribute to our communities' understanding of the transformative power of art and their greater commitment toward protecting and preserving what is unique in the Northwest. We are extremely pleased that the Boise Art Museum will share in developing this sense of community. Sandy Harthorn, Curator of Art, has been especially supportive throughout our entire process of organizing the exhibition and now enthusiastically has endorsed our tour.

Finally, in any exhibition there is never a dull moment behind the scenes. At the Western Gallery, responsibility for supervision of interns, as well as transportation and installation of the artwork, rests in the highly capable hands of Paul Brower, whose patience exceeds the gold standard. Sonja Chorba and David Brown at the Western Washington University Foundation provided good advice and direct assistance in fundraising. With a strong belief in interdisciplinary studies and community partnerships, Ron Riggins, and, now, Dan Guyette, Dean of the College of Fine and Performing Arts, have been exceptional in their encouragement. At the Hallie Ford Museum of Art, we wish to thank collection curator Jonathan Bucci, education curator Elizabeth Garrison, exhibition designer/chief preparator David Andersen, administrative assistant Carolyn Harcourt, receptionists Betsy Ebeling, Bonnie Schulte, and Linda Horton, security officer Frank Simons, and custodian Cruz Diaz de Estrada, for their help with various aspects of the project. If it "takes a village to raise a child," it also takes a village to organize an exhibition, publication, and regional tour, and we are extremely grateful to everyone involved who helped bring this project to fruition.

SARAH CLARK-LANGAGER
Director, Western Gallery, Western Washington University

JOHN OLBRANTZ
The Maribeth Collins Director, Hallie Ford Museum of Art, Willamette University

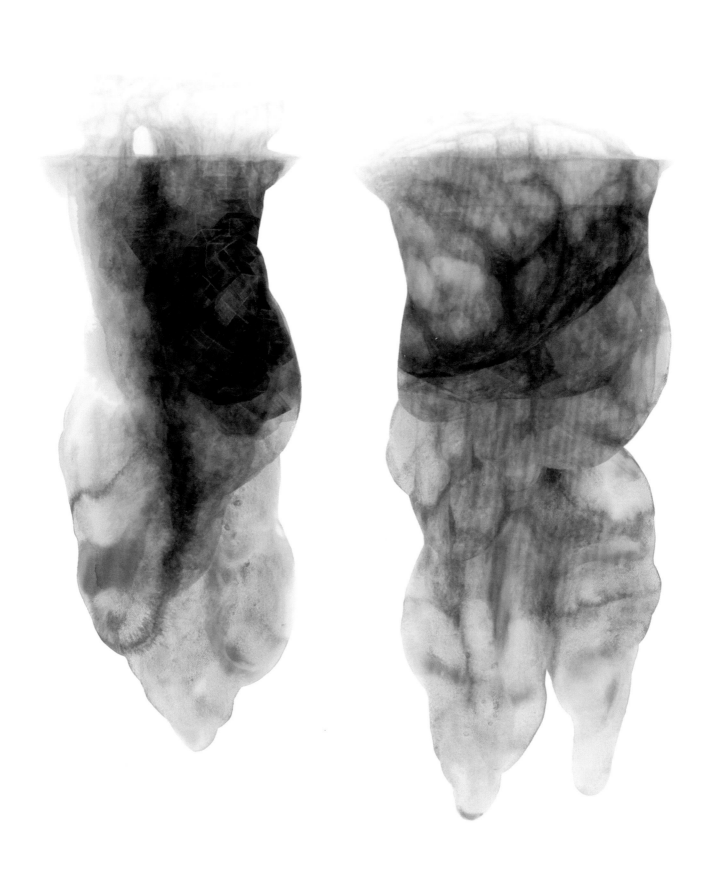

MESSENGERS IN THE NORTHWEST

SARAH CLARK-LANGAGER

INTRODUCTION

This exhibition focuses on the critical messages of artists who are deeply concerned with the issues and contemporary conditions of the environment in the Northwest, and the array of issues that encompass them. In their work, these artists draw on both the environmental politics long associated with the Northwest and the artistic history of these issues in the regional and national scene.

In the past, the consciousness of the Northwest has incorporated individualism, the romantic notion of the sublime space of the West, and Asian roots of mysticism, among other perspectives. Its outward manifestation has consisted not only of energetic settlers and builders of technology but also an avid pursuit of recreational interests uniting man and nature. The artistic theme of this dialectical relationship between man and nature has ranged from the early, mystic painters of the forties and fifties to the land-based art of the late sixties and seventies. The artist Dennis Oppenheim, for example, who was born in Washington, first worked in the fields of Montana where he began to use the earth as a material to emphasize the processes of art-making while celebrating the cycles of nature. However, it was the wider environmental consciousness of the Northwest that in 1979 brought artists together in

Seattle to form a national symposium on "land reclamation as sculpture." Both regional and national artists intercepted the social function of the landscape architect and made proposals to clean up the environmental degradation of mining operations and urban landfills.

During the eighties, artists in the Northwest, as elsewhere, shifted back to the other side of the nature/culture dichotomy to identify more closely with culture and the by-products of urban society. Rather than attempting to make sense of their natural, physical environment, artists focused attention on their social and political surroundings by claiming and recreating their personal identities and narratives. By the nineties, in response to the increasingly jeopardized landscape, artists heightened their focus on education through community-oriented projects. The California artists Newton and Helen Harrison made a conceptual design for the reclamation of Pacific Northwest forests, to give one example, and Northwest artist Buster Simpson decoratively glazed a set of ceramic plates by using the staining contaminants of polluted rivers from New York to Seattle. Today, in addition to public ecological projects, artists are broadening environmental awareness through the more traditional formats of painting, photography, prints, and sculpture in gallery and museum settings.

In their approach to these environmental concerns, some contemporary artists face the critical issues head on: growth management as seen in the urban/rural conflict; the connection of transporta-

(LEFT) CYNTHIA CAMLIN
Melted # 6, 2008
Watercolor, ink, and acrylic
60 x 52
Courtesy of the artist, Bellingham

tion and urban sprawl; contested sources of energy; mass production and consumption; toxic management of land, watersheds, and waters; and dramatic climate change. Others accent environmental values such as preservation of wilderness and wetlands, sustainability, and biodiversity; some even work this interest out through the strategy of artist and nature as co-agents. Finally, some artists have chosen to enhance the impact of current conditions and challenges by capturing their apocalyptic vision through poignant and dramatic renderings. In this exhibition the viewer will not only have a chance to see the overlapping causes and effects of these issues in the artworks themselves, but also to hear the resounding voices of our artistic messengers.

GROWTH MANAGEMENT

Jana Demartini has watched the western Oregon rural landscape being literally turned over into suburbia. In several of her prints she focuses on the bulldozer as the agent of this change. She pinpoints the cause of this rural/urban conflict by contrasting the mechanical structure of the bulldozer with the organic patterns of the earth. She enlarges the tracks of the machine diagonally across her sheet of paper, or deposits the remnants of the landscape on the machine's blade as if it were a canvas. In turning the excavator into an artificial arm and hand, she digs deeper to demonstrate exactly who is removing the features of the rural landscape. Philip Govedare occasionally leaves Seattle to go to the high desert and mountainous areas of the West. In his paintings, such as *Excavation*, he responds to what he has observed in this vast area: the building of roads, bridges, and dams, the stripping of mountains, and the resulting change in the types of lights in the sky. He organizes his painting so that it captures both his emotional response to the development and to the land's transitional moments from past to present to future. Lanny DeVuono's American Short Stories series holds small paintings with large implications: telephone poles, power lines, and nuclear cooling towers isolated against the sky; aerial views of farmland wedged between bulldozed lots and highways. Painted on wood and frequently labeled with text, the paintings literally become boxes of

plots of "grass," sections of a "crop," or "parcels" of land.

TRANSPORTATION

In DeVuono's *American Short Stories #40* the artist maps a real estate development, a residential community on the outskirts of a city. Some artists are concerned with the transportation problems that such sprawling, low-density development, characteristically including cul-de-sacs and strip malls, produces. Roll Hardy concentrates on the urban results of the freeway system that connects these bedroom communities. In his painting *Uphill Battle*, the freeway system not only engulfs the entire view but also creates worn-down, deserted spaces where human activity once thrived. Views from under the dominant freeway in *Hazy Afternoon* compress the typical grayness of the Northwest hanging in the air, now compounded by the vapors of old industrial plants and auto emissions. In thinking about the grand traditions of landscape art and spectacular views in the Northwest, Chris Jordan adapted Ansel Adams's shot of Mount McKinley in Alaska's Denali National Park. He blocked this famous view by pixilating Adams's photographic image into 24,000 rectangles composed of altered and unaltered GMC Yukon Denali SUV logos. The number of Denali logos represents six weeks of the vehicle's global sales and, hence, the gas consumption of the SUV in 2004; alternating with the GMC logos is the anagram of Denali—the word "Denial."

SOURCES OF ENERGY

Chris Jordan subtly pulls us into the majestic view of the Alaskan mountain as if he had created a large pointillist painting. Yet instead of being absorbed by a field of colorful dots we are thrust into commercial logos and into thinking about our lifestyle and consumption of energy and their combined results on the natural landscape. In his photograph of *John Day Dam* Steve Davis edits his view to create a dreamscape; he leaves the bedroom window open to the distant view of a part of the Columbia River Basin's system of dams. Here, in place of Jordan's satire, Davis sublimates or pushes to the back-

ground the pressing issue of the presence of dams on rivers for hydroelectric power versus the restoration of salmon. We are pulled back again to question the photograph on the bedroom wall, which seems to depict these historical events in biblical proportions.

MASS PRODUCTION AND CONSUMPTION

Michael Brophy is known for his logging and fishing scenes of the Northwest. In addition to providing contemporary viewpoints on the changes in the regional environment, he has pointed to historical events, such as the effects of early commerce and trading on native cultures. In his painting *Beaver Trade*, Brophy placed the carved statue of George Simpson, head officer (1821–1856) of the Hudson's Bay Company, on top of a carved native pole marred by large shoe prints and *X* marks over the eyes of the iconic beaver. Simpson's gaze toward the setting sun over the flooded Columbia River relates to his company's dramatic but advantageous decision to end all the fur trade in the Oregon Territory. He wanted to stimulate the river basin in a newer, more profitable manner, which eventually resulted in the growth of Portland. Both Brophy and Craig Langager draw upon the flora, fauna, and bountiful landscape of an earlier America but create a decidedly postmodern mood. In Langager's sculpture *Tille, All Primped and Ready for Wall Street*, the large vulture perches on a photographer's tripod, part of the tool that enabled those nineteenth-century artists to make and sell their heroic views of the western landscape to the public. Having consumed the vistas and fauna through rampant development, the vulture, a surrogate for human activity, now turns his newly developed tool—his lobster claw–like mentality toward day trading and thievery in the stock markets and the sale of carbon credits on the exchange.

Unlike Brophy and Langager, Karen Rudd has a more positive approach to resource extraction. Her sculpted tree stump, *Last Stand: Cedar*, refers to the traditional economic base of the region. Her use of large scale and positive/negative space emphasizes the harvesting of old-growth timber. Being concerned about consumerism, she crafted the tree out of cardboard—one of its end products—yet her material is nevertheless recycled pulp. The fact that we have recycling bins does not stop Chris Jordan from believing that much of the long life of our discards is glossed over, unseen, and out of control. In his photograph *Plastic Bottles* he focuses on the scale of what we have made disposable, and our wasteful habits.

WASTE MANAGEMENT

We are drawn to the vast expanse of Jordan's landscape until we realize up close that the landscape is compacted litter—bottles of all types and shapes—as far as the eye can see and beyond. The same dichotomy of attraction/repulsion is a part of Steve Davis's photograph of *Lime, Oregon*. Silvered and aged, the facade of the mining company looms up like an apparition. The decayed building rests on a bed of its own making; its industrial waste, polluted or not, slowly seeps back into the earth.

Beyond the destructive effects of society's garbage and toxic waste on the land, several artists focus on the conditions of our watersheds and waters. In her paintings, such as *Limited Vision* and *Construction II*, Margaretha Bootsma explores the cumulative effect of fuel consumption and industry both on and off shore on the Puget Sound ecosystem. As she recombines fragments of photographs of such subjects as highway signage, industrial plants, and human forms, with various painting materials, formal devices, and expressive color, she alludes to the collision of urban recreational and industrial uses of the water, and ultimately the pollution of the oceans.

In addition to their interest in Puget Sound, several artists are concerned about Northwest rivers. Mark Ruwedel decided to journey down the Columbia River soon after the Environmental Protection Agency declared (1989) that the Hanford Reservation was the world's largest environmental cleanup project. In both of Ruwedel's photographs from The Hanford Stretch series we initially identify with the recreational aspects of the mighty river through his depiction of the beached canoe and fishing boat. However, it is the nuclear reactors and the transmission lines on the distant shores that supply the real story behind the dead Chinook be-

side the fishing boat. Ruwedel's series explores the effect of radiation poisoning generated by the nine nuclear reactors operated by the government from 1944 to 1971. Their main radioactive release—iodine-131—not only spewed downwind but also recycled through the cooling system to contaminate the drinking water.

Over twenty years ago, Robert Dozono began to collect litter from the banks of local rivers and to literally incorporate it into his paintings of the same sites. His tribute to the Upper Clackamas River in Oregon demonstrates his practice of repurposing wasted or cast-off resources, even the "veggie dog." Yet the crosslike structure of the large-scale painting embedded with the local garbage makes us question what we must sacrifice—our reckless habits or our rivers. Buster Simpson too, since the seventies, has responded to several environmental problems, especially those pertaining to water. One of his latest public projects, *Walla Walla Campanile: Instrument Implement*, combines sculpture, sound, and scientific data to create a test for a healthy watershed from Titus and Mill Creek to the Walla Walla River and the Columbia River. As he elaborately details in his statement for this catalogue, the sculpture has several focal points, one being the female canary yellow salmon in a cage or net, a metaphor for the condition of the surrounding ecosystem.

CLIMATE CHANGE

Perhaps Michael Brophy's painting *Blowdown* is most symptomatic of the present discussions surrounding the issue of climate change. While earlier generations found paintings of the untamed wilderness and mountainous peaks and crevasses awe-inspiring, artists today gather the terrifying facts of consumption and waste and frame these issues by bringing them into their larger setting—the dramatic changes in weather patterns. In Brophy's painting one does not know whether the heroic pileup of felled trees stems from logging practices, ocean debris, or storms. In Philip Govedare's painting, *Flood*, the enveloping clouds meld the ice peaks, rivers, lakes, and ocean into one watery landscape suffused with the red light at day's end. His reconfiguration of the landscape into one flowing with

expressive color establishes a mood of memory and loss. Cynthia Camlin, while aware of the picturesque tradition of the sublime, the terrifying, and the beautiful, is interested in getting us to understand climate change by allowing us to see and to feel ice melting before our eyes. Rather than rendering the ice caps and ice fields of the Northwest, she abstractly captures ice's crystallization pattern as it surfaces for a moment, then dissolves into pools of blue and green pigments. Meanwhile, the entire surface of her forms in *Melted # 6* and *#10* moves across her large sheets of paper. Anna McKee is also interested in the essence of ice but has gleaned her information from visits to Alaska and, most recently, West Antarctica. She bases her abstract prints on her own sketches of glaciers and ice sheets as well as high-resolution photographs of ice cores and Ice Penetrating Radar imagery. Similar to the way ice cores also hold ancient dust, chemicals, and atmospheric gas, McKee uses multiple print techniques (etching, chine colle, collography) to give a layered sense of climate changes, as in *Ice Sounding/At the Divide* and *Memory—Easton Glacier*.

All the artists whose work has been described so far have examined the impact of societal development on natural resources, some remaining nonjudgmental or questioning, while others appear to offer no way out. Yet other artists value such environmental attitudes as conservation, sustainability, and biodiversity.

PRESERVATION OF WETLANDS AND WILDERNESS

Both Steve Davis and John Grade have created work using the subject of wetlands. The presence of a dike across the entire background of Davis's photograph *Nisqually* confuses us as to just what we are observing—intervention or reclamation—as his image shows the early stages of a dike being constructed in the Nisqually River Delta. The Nisqually Indian Tribe and Ducks Unlimited have been working together in this national refuge to first remove the old dikes that pioneers built in the late 1800s and early 1900s to create rich farmland. In turn, they have constructed a new dike that controls the confluence of fresh water from the

Nisqually River and saltwater from Puget Sound yet also creates a delta. Altogether this is one of the largest recoveries of the region's great estuaries. Grade first placed his performative sculpture *Collector* in the Willapa National Wildlife Refuge, which has a wide variety of wetland habitats including fresh and saltwater marshes, tidal estuary, ponds, streams, and seasonal wetlands. During his stay at Willapa Bay, Grade has reported seeing feuds over the methods of how to farm oysters—one side wanting to preserve wetlands and the other using chemicals for more efficient harvesting. While these wetlands support overwintering migratory birds, it was small birds in Utah that finally picked his sculpture dry there.

In his painting *Tree Curtain*, Michael Brophy refers back to the nineteenth-century tradition of such artists as Charles Wilson Peale and Frederic Church; Peale used the image of a curtain, and Church put an actual one over his paintings so he could reveal them in a dramatic fashion. It was a motif they chose in order to enhance their own artistic revelations about America's scientific wealth and the splendor of the West. In Brophy's time, the curtain opens instead to reveal the demise of one of the Northwest's natural resources. Just as Brophy selects the curtain motif to set the stage for his Northwest story, Robert McCauley uses a wide variety of framing devices and text to help the viewer reexamine his relationship with the landscape. Although titled *American Metaphor: Cultured Garden or Raging Wilderness*, this painting, as well as many other examples of his work, has the dense, dark, and gloomy atmosphere so characteristic of the landscape west of the Cascades. To McCauley, nature is a stage set. The heavy, windowlike frame clearly separates the physical world from the dramatic scene generated by the artist. Moreover, the frame —with its script—sets up the debate that rages within. Both McCauley and Laura McPhee are aware of the dilemma that the governmental regulation of forest fires presents. In her photograph *Understory Flareups . . .* she captures the naturally occurring wildfire at Fourth of July Creek and Valley Road in Custer County, Idaho. Through the size of her color photograph, reminiscent of grand nineteenth-century landscape paintings, and through

the use of her predecessors' large-scale view camera, she places us within the forest and at the foot of the burning log. The shafts of light breaking through the trees dramatize the forest's majesty but also reveal the simmering and smoldering brush whose loss, ironically, will insure its longevity.

James Thompson's abstract prints, such as *Talus* and *Liminal*, are a way of investigating the landscapes of Oregon, Nevada, and Utah, which vary from wetlands to grasslands, desert and dry rivers to lakes, and mountain peaks to forest floor. Concerned about development and land use, he turns the negative aspect of the phrase "vanishing landscape" into a positive reflection. The manner in which he executes his prints is similar to the way people can and have reshaped the land over time. He finds his fields in the blank zinc plate, where they wait for his industrial grinding tools that allow him to carve deep furrows. He combines the intaglio process with drawing and painting on the surface of the plate and continuously changes the plate each time he passes a print through the press. Some marks on the plate are preserved while other areas are sustained through new hand-work on the surface. Marks on the plate and on the land create new conditions that require repeated observations, as in *Furrows* and *Subaqueous*.

SUSTAINABILITY

In the Native American tradition, people bound their whole individual and communal selves with the land, an early and powerful example of sustainable living. In Rick Bartow's sculpture *Salmon Prayer*, the personal and the shared are at the center of the work. A man is lying inside the entire length of a salmon; his face emerges in the salmon's mouth where both utter their common prayer of endurance. In *Salmon Chant*, Bartow begins with the myth honoring the fish and the stewardship of the waters. Through overlapping patterns, splashes of expressive color, and gestural line, his aim is to personally capture and embody the earlier well-being of the natural world. Jan Hopkins has adapted the indigenous peoples' functional process of fish-skin basketry to her own contemporary art. In her *Sturgeon Vessel*, she accents the length of the skin through

the vertical shape and highlights the delicacy and translucence of this native resource by adding ostrich shell beads. Here, unlike the way Dozono employs recycled litter, she directly selects alternative materials such as grapefruit peels to create *Spellbound*, a vessel that undulates with its rounded shapes and wrapped words.

ARTIST AND NATURE AS CO-AGENTS

Whereas Bartow is interested in the transformative aspects of myth in *Salmon Chant*, John Grade is literally a co-agent with nature in creating his sculpture and installations. While Buster Simpson, as mentioned earlier, involved himself physically in his work by wading into polluted waters, or recently by combining scientific data from the Walla Walla watershed into his public sculpture, Grade's co-agency is more encompassing on a different intellectual level. In 2008 Grade wrote that he was interested in designing work that would change and be changed in various types of environments, whether forest, mountain, ocean, or desert. He sees his body as a part of those ecological systems, both in the sense that he travels, explores, works, and plays in the outdoors, and in the fact that he intellectually knows he is part of the same natural cycles of creation and destruction, formation and erosion, growth and decay. The title of his sculpture *Collector* references his idea of connecting diverse landscapes—patterning an arc taken from a slot canyon in the Southwest to placing its wood version in a Northwest bay. It also refers to the sculpture's temporary function as an oyster and crustacean catcher in Willapa Bay. The documentary photograph of Grade carrying the sculpture on his back was intentionally planned so that, now with hornlike wings, he walks away, mirrored in the ocean.

Vaughn Bell combines the public nature of Simpson's projects and Grade's intimate involvement with nature in her biospheres. These versions of *Village Green* are portable miniaturizations of the landscape. Viewers are allowed to place their heads inside acrylic structures that contain, for this exhibition, real greenery from the Northwest landscape. Yet being up close and personal with the landscape involves responsibility. To underscore the goal of a

mutually beneficial relationship between man and nature, the exhibitor or owner must sign adoption papers, which include instructions for care. There is humor, irony, and even threat in Bell's approach. In her work we are glimpsing a collapsing of the two categories of nature and culture at the same moment our natural environment becomes more and more man-made.

BIODIVERSITY

In placing their emphasis on the long-term well-being of humans and natural resources, some artists bring their attention to bear on the environmentalist's valuing of biodiversity. In her photograph *Red Fladry to Spook Wolves and Deter Them from Killing Calves, Fourth of July Creek, Custer County, Idaho*, Laura McPhee asks the question of how well we coexist with wild animals when our livelihood and survival depends on that relationship. In this case, McPhee later reported that in the contested relationship of science and landowner the ranchers' method did not work. By contrast, Nancy Loughlin's painting *Reclamation* is a clear endorsement of nature's ability to reclaim itself and its old territories. Through the juxtaposition of birdcages, birds on limbs and in flight, and wolves roaming both outdoors and in interior settings, all within the strong framework of a doll-like house, she examines how we must live in an ecosystem that is larger than our own dens filled with artificial décor and decorative objects that only reflect nature.

Susan Robb uses science and invented communication to reference biodiversity and the adaptive methods of plant life in face of invasive species. *Signal Transduction Knowledge Environment* is a flower garden constructed of wire and audio equipment. The fact that the whispering tones of the garden sound like birds in flight yet stem from human language is symbolic of our interwoven lives. Nevertheless there is something unsettling about the whispered message—"It's in the air. It's in the water." In contrast, Matt Sellars's superb craftsmanship and use of natural woods offer a soothing respite from a society filled with high technology and plastic. Following his admiration for fishing boats, he placed a series of carved trawlers on a table

as if ready for loving handling. There is a circular dynamic in several of Sellars's sculptures that reflects his concern for loss of natural resources resulting from an abundance of goods and the accompanying industrial effects. In *Empty Quarter*, the boats lean into the cut-out waves that open up only to the dead zones now evident in the shallow coastal waters of the northern Pacific Ocean.

APOCALYPSE

Traditionally, the biblical term *apocalypse* has referred to the ultimate destruction of evil and the triumph of good. In contemporary terms, author Ira Livingston has stated that the dark twin of sustainability is apocalypticism. He offers the comparison that sustainability is a kind of background noise humming continuously in our lives—the sound of the decline of the West and/or life on the planet Earth. At one end of the spectrum he regards sustainability as a kind of pill that soothes symptoms of decline, a kind of anti-apocalyticism. At the other, he presents the challenge that sustainability can be itself a kind of apocalypticism, an opportunity extending over the whole range of our lives.

In her sculpture *Using De Maria's Lighting Rods, The Animals Stage a Valiant Surrender*, Susan Robb sees violence as a mode in the changing of the world's ecology. A pole with a white flag of feathers, hides, and fur rises amid a pile of dark plastic rocks and evokes the image of the raising of the American flag on the island of Iwo Jima during World War II. Overall, she sees the ecological crisis as an ongoing attack; the animals fight back the onslaught of the man-made, and nature still unleashes its power with tsunamis, hurricanes, and tornadoes. Yet as we have seen in Craig Langager's sculpture *Tillie, All Primped and Ready for Wall Street*, a ravaged drama and a wounded glamour, his sculpture *Bennie Cloned* offers up another specter—the new age of biomimicry. During the eighties Langager created large-scale installations in New York and Boston that dealt with extinction, mutation, and cloning. Bennie, with his luscious feathers and possum face, shows us that something can look appealing on the outside yet be sinister on the inside. We are left to debate whether Bennie is a laboratory experiment gone awry or if his cloning is a convenient way to furnish our needs.

In referring to her iceberg paintings as having "monstrous depths," Cynthia Camlin has caught the character of something we have always feared about their scale and unseen expanse, whether in glaciers in the mountains or floating in the sea. Now having extracted the iceberg from these traditional surroundings, she concentrates on the pooling of pigments across the surface of her paper where, as in *Melted #5*, she evokes the darker reality of global warming and disaster.

Adam Sorenson also believes the present developments in ecological conditions call for a new way of imagining the landscape. While he references the heroic, nineteenth-century landscapes of such artists as Frederic Church, he expands their grand idealized views by adding abstract, expressive strokes, chromatic transitions reminiscent of computer graphics, and the electric, acidic colors of Japanese anime. Through change of scale, juxtaposition of patterns, and distortion he both startles and seduces us. Perhaps his paintings *Banks I* and *Hide Out* bring us closer to examples of the post-apocalyptic landscapes of the future that Livingston has envisioned.

+ + + +

With the diversity of their critical messages, the artists in this exhibition offer us a complex view of our present situation. They allow us to witness the many ways that contemporary art can help us recollect our past natural environment yet call us into a new relationship with its present decline. The artists wish to integrate their knowledge and aesthetically creative images into our discussions about our world where contemporary technology has now actively begun to blur the boundaries between the natural and the artificial, between nature's creation and man's productions.

SUGGESTED READINGS FOR BACKGROUND

Avigikos, Jan. "Green Piece." *Artforum* (April 1991): 105–110.

Boettger, Suzaan. "Global Warmings." *Art in America* (June/July 2008): 154–161, 206–207.

Brookner, Jackie, ed. "Art and Ecology." *Art Journal* 51, no. 2 (Summer 1992).

Cembalest, Robin. "The Ecological Art Explosion." *ARTnews* (Summer 1991): 97–105.

Cembalest, Robin, ed. "Turning Up the Heat." *ARTnews* (June 2008): 102–115.

Langager, Craig. "Getting the Symposium off the Ground. A Process in Itself." *Earthworks: Land Reclamation as Sculpture*. Brochure. Seattle: King County Arts Commission, July 1979.

Livingston, Ira. "Sustainability and Apocalypticism." *PRATTfolio* (New York: Pratt Institute of Art), Spring 2008: 46–47.

Markonish, Denise, ed. *Badlands: New Horizons in Landscape*. North Adams, MA: MASS MoCA, 2009.

Morris, Robert. *Earthworks: Land Reclamation as Sculpture*. Seattle: Seattle Art Museum, 1979.

Matilsky, Barbara C. *Fragile Ecologies: Contemporary Artists' Interpretations and Solutions*. New York: Queens Museum of Art and Rizzoli International, 1992.

Smith, Stephanie. *Beyond Green: Toward a Sustainable Art*. Chicago: Smart Museum of Art and University of Chicago; New York: Independent Curators International, New York, 2006.

Wolff, Rachael. "Turning Over a New Leaf." *ARTnews* (April 2009):88–95.

SELECTED READINGS ON ARTISTS

Extensive biographical and bibliographical material can be found at the individual artist's Web sites or on the Web sites of their gallery representatives. Highlighted are the following catalogues:

DeVuono, Frances. *John Grade: Seeps of Winter*. Brochure. Seattle: Suyama Space, 2008.

Hushka, Rock. *The Romantic Vision of Michael Brophy*. Tacoma, WA: Tacoma Art Museum; Salem, OR: Hallie Ford Museum, Willamette University, 2005.

Miller, Barbara L. "Cynthia Camlin's Self-Organizing Icecaps." Brochure for exhibition. Seattle: Monarch Studio, 2008.

Running the Numbers, An American Self-Portrait: Chris Jordan. Introduction by Chris Bruce. Essays by Lucy Lippard and Paul Hawken. Pullman: Museum of Art, Washington State University; Munich: Prestel Verlag, 2009.

Sayre, Henry M. *James B. Thompson: The Vanishing Landscape*. Salem, OR: Hallie Ford Museum of Art, Willamette University, 2009.

(RIGHT) SUSAN ROBB
Signal Transduction Knowledge Environment (detail), 2006
Four-channel audio, clay, speakers, and wire
48 x 180 x 48
Courtesy of the artist, Seattle.

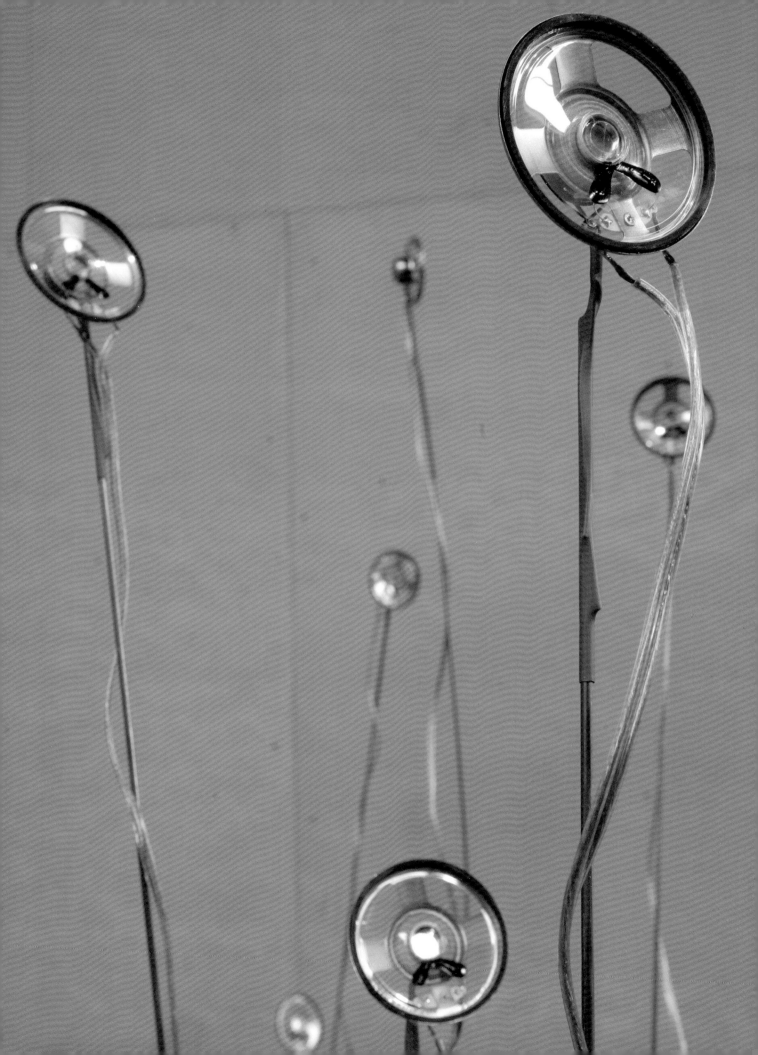

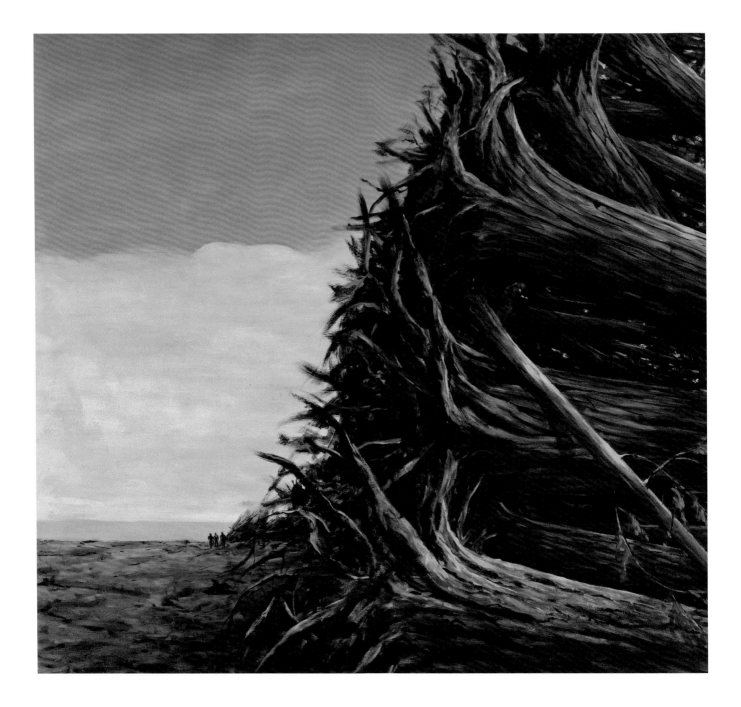

ON THE BRINK: A PORTRAIT

WILLIAM DIETRICH

"Nature is a revelation of God," Henry Wadsworth Longfellow wrote. "Art is a revelation of man."

And environmental art in the Pacific Northwest is necessarily a revelation of both. We of the twenty-first century are the inheritors of spectacular, almost ethereal beauty—a quilt of sea and land, rainforest and desert, canyon and volcanic peak, glacier and coulee. But it is an environment that has been drastically altered in the past two hundred years, and is under siege from planetary change. The composition of our atmosphere, the chemistry of our seas, and the mix of native and alien species are changing as we escalate our domination of the Earth. Technological cleverness has outrun stewardship wisdom, and we look to artists to help us make sense of our handiwork and folly as they contemplate the most dramatic ecological change the planet has experienced since the end of the last Ice Age.

It's not surprising that artists are addressing the Northwest environment, melding the objectivity of physical reality with the interpretation of the human mind. Humankind's earliest art was environmental. The sinuous animals of cave paintings and petroglyphs reflected our dependence on, and respect for, the natural world and its bounty. Succeeding civilizations saw artists concentrating on

(LEFT) MICHAEL BROPHY
Blowdown, 2007
Oil on canvas
74 x 80
Collection of Bill Driscoll and Lisa Hoffman, Tacoma, Washington

the mythic, the human, the religious, the political, and the mind in turn. Today our collective unease over the future of the Earth is reflected in a return to the central preoccupation of our prehistoric ancestors. What is man's proper relationship to nature? Yet this is ecology and people, both portrayed in a more varied and sophisticated way than cave paintings. Environmental art is a new kind of mirror, a reflection of our past and a crystal ball holding visions of the future.

To explain this exhibition, it is necessary to summarize some of the real Northwest issues that these artists metaphorically interpret.

First, for those of us privileged to live here, let's admit the cheerful chauvinism that permits (nay, requires) that we call the Pacific Northwest the most beautiful place on earth. Our cathedrals and castles are wildflower meadows backed by glaciers, aquamarine river pools clearer than glass, craggy headlands that boom with a symphony of surf, and desert canyons that are a rainbow of rock. In this volcanically active, rising edge of a dramatic West, we experience glorious extremes. The Olympic rainforest is soaked by up to two hundred inches of rainfall a year, and Mount Baker holds the world's record for snowfall at 95 *feet*, enough to bury all but the central tower of the Whatcom Museum of History & Art in downtown Bellingham. In contrast, the sage steppe at the atomic reservation at Hanford lives on as little as 5 inches of precipitation. In Idaho, the Big Lost River simply disappears into Snake Valley basalt,

while the aquifer reemerges at Thousand Springs with a profusion of waterfalls. Mount Rainier surges nearly from sea level to almost three miles high, while Hells Canyon is deeper than the Grand Canyon, and Craters of the Moon has a rift crack that, at 800 feet, is the deepest on earth. In spring the rolling green wheat fields of the Palouse, crested with snow, are a storm at sea. Oregon's Steens Mountain is a lonely ship, a single mountain nearly fifty miles long with a peak nearly two miles high. Ohanepecosh old growth is one of our ancient forest temples, and Washington and Oregon are dotted with world-record trees, the highest approaching three hundred feet. Oregon Dunes is our Arabia, and Idaho's River of No Return is just the kind of place you want to go back to, a roller-coaster ride of a hundred rapids that race, roaring and foaming, from alpine forest to canyon desert.

The landscape gives tremendous poetry to its names, a song worthy of the imagination of Tolkien. How splendid to live amid Mount Olympus and Mount Terror, Crater Lake and Rooster Rock (named by pioneers for its phallic boldness), Damnation Creek, Enchanted Valley, Hurricane Ridge, Rogue River, Paradise, Point No Point, Cape Disappointment, and Skykomish, Humptulips, and Walla Walla. Our environment restores the soul and inspires the imagination. It's the job of a lifetime to take it all in.

We humans have added our own landmarks: the largest building in the world at Boeing's Everett assembly plant, the world's longest railroad tunnel under Steven's Pass, the world's three longest floating bridges, and, at Grand Coulee Dam, the world's third-largest concrete structure and the nation's biggest producer of hydroelectricity.

But let's also admit how clumsy, and even disastrous, our stewardship has been. We benefit from clean hydroelectricity, but we also have the most intensively dammed river network in the world, a blockage of two thirds of our stream miles that has contributed to a roughly 90 percent decline in wild Columbia River salmon runs. The Hanford Nuclear Reservation has been called the most polluted place on earth, and the effort to clean it—now expected to drag on until 2047—is projected by the federal government to cost between $86 billion and $100 billion by the time we are done. We have eliminated most of our lowland old-growth forest, most of our sage steppe ecosystem, and half of our estuarine wetlands. Endangered species range from the pygmy rabbit to the spotted owl to resident killer whales. Seabirds are in mysterious, troubling decline. We clear, pave, and build on nearly 50,000 acres of land each year, on average, in Washington alone.

Washington's population has nearly tripled since 1950, to 6.7 million, and the federal government estimates another 2 million will live here by 2030, one generation away. Oregon is projected to gain 1.3 million, Idaho 450,000, Alaska nearly 200,000, British Columbia 1.3 million. In other words, the Northwest as a whole is projected to add the equivalent of ten cities of Seattle in just the next twenty years.

Or, to look backward, by 2000 Washington had eighty times as many people per square mile as it did in 1880.

While Eden is more crowded, it could also be argued that our environmental nadir, in terms of intense exploitation of natural resources and a lack of environmental regulation, occurred half a century ago. Since then the air and water have arguably been getting cleaner, not dirtier, because of cleaner cars, controls on factory emissions, and improved sewage treatment. Hazardous waste generation in Washington was cut in half just in the 1990s. Recycling has steadily grown. Growth control has become more sophisticated. Lands under protection have increased, not declined. Northwest cities continue to develop mass transit, and environmental volunteerism has exploded. Energy conservation has accelerated. Wind farms have joined hydro as sources of clean power. Environmental science has made huge leaps forward.

Are all those new people contributing solutions as well as problems? That must be our hope.

We are in a fact in a race between our own numbers and pollution control, between industrialization and cleanup technology, between consumption and conservation. It is this mix of failure and success, despair and optimism, decay and progress, that makes our attitude toward the environment so complex and confused. Art helps inform our thinking, and our thinking informs our art. The pieces in this exhibit touch our thoughts, our feelings, our fears, and our joys.

Environmental reform in the Pacific Northwest can be broken into at least three eras, each building on the other.

The first was land preservation in response to the unbridled resource exploitation of the nineteenth century. Reform led to the creation of the national park system, national forest system, wilderness system, and a gradual shift in public lands management from purely economic exploitation to ecosystem restoration. This contentious and painful shift is still going on today, for example, with the debate about natural forest fires as a tool to sustain the environment.

The second era was the regulatory movement that began in the 1960s following publication of *Silent Spring* and press coverage of a mounting list of environmental horror stories. The result was the creation of the federal Environmental Protection Agency, its state counterparts, and passage of a host of fundamental environmental laws such as the Clear Air Act, Clean Water Act, and Endangered Species Act. While regulation has been contentious, the long-term trend over four decades has been a steady ratcheting up of emission controls and slow cleanup of past mistakes. While estimates vary, several studies suggest the annual U.S. cost of this to business and taxpayers is about two percent of the nation's gross domestic product.

The third era, underway now, is shifting the focus from government rules and factory emissions to individual action. People are being asked to conserve energy, recycle waste, reform their consumption habits, and even consider how many children they should have. County-based land trusts have, collectively across the United States, protected as much land as the national park system in the Contiguous 48. From hybrid cars to vegetarian diets, home solar to smart-growth neighborhoods, ordinary Americans are taking responsibility for global change.

New urgency comes from fear that greenhouse gases are changing the climate, that carbon absorption is acidifying the oceans, and that overcutting and industrial farming are leading to environmental collapse in parts of the world. The result could be failed states, resource and water wars, and terrorism. Even as environmentalists see encouraging progress in some areas, new challenges threaten to trump all.

So we turn to artists to help make sense of it all, or plumb our feelings, or touch our souls. The *Critical Messages: Contemporary Northwest Artists on the Environment* exhibition was organized around eight underlying issues identified by Northwest environmentalists. They are growth management, waste management, production and consumption, transportation, wilderness and wetland preservation, biodiversity, climate change, and energy.

All of them, but particularly growth management, ultimately stem from our astounding and frightening success as a species. It took a million years of evolution and history for *Homo sapiens sapiens* (which means wise, wise, us) to reach 1 billion people, at the end of the Napoleonic Wars and at the start of the Industrial Revolution. Then just one hundred years to reach 2 billion, fifty years to reach 4 billion, and another fifty to reach almost 7 billion today. While the birth rate is declining, birth numbers remain high because the base population of young parents is so huge. As a result, world population increases by more than 200,000 people each day. In the Pacific Northwest, it has been increasing the past couple of decades by an average of about five hundred newcomers per day, more in boom times and less when the economy slows.

Regardless of whether you view this as good news or bad news, it is certainly big news.

Most of the newcomers settle into an urban corridor along Interstate 5 and Highway 99, which stretches, increasingly unbroken, from Vancouver, Canada, to Eugene, Oregon. Other urban nodes such as Spokane, Boise, Bend, and Anchorage also emphasize our transition from the largely rural, resource-based society of a century ago to the urban, brain-product society of today. Affordable housing is increasingly multifamily, and as we live closer together we inevitably adopt more rules to govern behavior and set boundaries on growth. The heroic Northwest individualist, wresting a living from nature, has been replaced by the cubicle software engineer and the retail barrista. Zoning is in a race with development to corral sprawl. The result is that most of us spend most of our time indoors. Nature is Out There, a thing to be visited instead of inhabited. How to integrate and balance the human and

natural worlds is one of our greatest creative challenges. How to retain a sense of individualized freedom in a dense, socialized world is a political conundrum that has polarized debate and produced more heat than light.

All these humans produce, and consume, a lot. One of the astonishing successes of civilization has been a rise in average global living standards despite (or because of) the population explosion. But creating, storing, and getting rid of this bounty is an increasing planetary headache.

Perhaps it is by Paleolithic instinct that so many of us are shoppers and hoarders, remodelers and auto enthusiasts, collectors and decorators, fashionistas and hobbyists. Not content with one cave, we take refuge in boats, cabins, resorts, tents, motor homes, second homes, motels, bed and breakfasts, casinos, and stadium boxes. Not only was there a time of no walk-in closets, once upon a time (not all that long ago) there were no closets—but don't kid me that you want that three-car garage today just for *cars*. It's for stuff! We buy stuff, trade stuff, give away stuff, and haul away stuff. The average American generates 52 tons of garbage by age seventy-five. Representing five percent of the world's population, we consume a quarter of the world's energy. We need it for our stuff!

A typical Northwest Native American longhouse might contain five to ten families and up to fifty people. Today, we average 2.5 people per American dwelling, down from 4.5 over the last century. And as the number of humans per domicile is declining, the size of the house is increasing. In 1940 the average American house was 1,400 square feet; now it is 2,330, according to the American Association of Home Builders. At the height of the recent mortgage crisis, one in nine of these bigger American homes stood empty.

We average 2.28 cars per household (or nearly a car per person), 2.1 televisions (over half of all U.S. households have three TVs), and are approaching one computer per person—probably more, if you count cell phones and gaming devices. We own a bit more than one dog or cat for every two people. We eat about a third more meat per person than we did in 1950, drink down 400 million cups of coffee per day, and average 27 gallons of beer per person per year. According to Consumer Reports Research

Center, American women average 19 pairs of shoes. We spend more of our gross domestic product on health care than any other country: almost twice the percentage spent by Australia, for example. Yet we have fewer doctors per capita and lower life expectancy than they do Down Under.

Our military spends nearly as much each year as all the world's other nations combined; about 4.8 percent of GDP, or two and a half times what we spend on the environment.

Of course all that stuff has to be disposed of, eventually. So even here in God's Country, we have a lot of waste depositories.

The Northwest used to be empty enough that it seemed a convenient place to put things more crowded places didn't want. We made plutonium for nuclear weapons at Hanford. Stored nerve gas in Umatilla, Oregon. Ran more than fifty test nuclear reactors at Idaho National Laboratory at Idaho Falls. Sickened residents with asbestos pollution from vermiculite mining in Libby, Montana. Turned the mining corridor along Interstate 90 in north Idaho and western Montana into a giant Superfund site. Operated a coal strip mine near Centralia, Washington, to supply the state's sole coal-fired plant until the mine closed in 2006; the coal now comes from Wyoming. We store much of the nation's active nuclear arsenal at the Bangor submarine base on Hood Canal. There is groundwater pollution at military bases, contamination of the soil at old port and mill sites, and former garbage dumps leak methane and pollutants. Like any industrialized area, the Northwest is also home to its share of refineries, smelters, and manufacturing plants. Many of the worst polluted areas are slowly being cleaned up, but at a combined cost reaching into the hundreds of billions of dollars.

The Pacific Northwest is also built around the automobile. Despite expensive experiments with rail transit in Vancouver, Seattle, Tacoma, and Portland, all these new people inevitably add to car traffic. While the number of miles driven has not risen as fast as population in Washington State, it still rose 30 percent over a 19-year period following 1984, according to State Department of Ecology records. More recently, however, vehicle miles dropped as the recession deepened. The bad economy has led to heartbreak for millions, yet environ-

mentally it prevented millions of tons of carbon from otherwise entering the atmosphere, the federal government reported in 2009.

While higher-mileage cars and more transit and bicycle opportunities tackle the problem from one end, the other solution is to move people closer to their jobs to reduce commuting. Governments have rezoned accordingly. One of the most dramatic changes in Northwest cities in the past generation has been the increase in demand for multistory, multifamily apartments and condominiums. This is creating an increasingly "smart-growth, new-urbanism" population that walks more and drives less. Even in suburbs, new urban nodes are changing the postwar landscape and pointing to a twenty-first century cityscape very different from the past. We still have a gluttonous taste for oil, however, fed by steady tanker traffic into the refineries and pipe-lines of Northwest Washington.

Climate change presents one of most perplexing challenges to our society. While there is little debate that climate changes over time, at this writing the debate over how quickly change is coming—and whether humans are responsible—seems to be dividing the public more than ever. So is the question of what to do about it. Northwest political leaders have been ahead of the curve in proposing reforms and solutions, but with China having passed the United States as the world's biggest carbon emitter, with India not far behind, few issues have appeared so huge and so intractable.

The potential impact of global warming on the Pacific Northwest could be enormous, scientists have warned. Droughts could cripple agriculture and spark disastrous forest fires. Warmer winters could allow survival of insects that devastate timber. Glaciers could disappear, dropping summer stream levels so low and making water so warm that the survival of fish is imperiled. Salmon spawning beds could dry up, or be washed away by storms fueled by a warmer atmosphere. Native species might decline and be replaced by those invading from the south. Ocean conditions could change, disrupting the nutrients marine life depends on, or allowing new diseases, algae blooms, and die-offs. Less snowpack could disrupt the production of hydroelectricity. City reservoirs could be strained. Energy demand for air conditioning could increase.

The likely solution is a combination of energy conservation and new "green" technology, but once again getting to that future will involve a race between our traditional fossil-fuel economy and challenging, expensive change. Will it be better light bulbs, a renaissance of massive nuclear power plants, or steps in between? How can we retain our high-tech, high-standard-of-living Northwest utopia while living more lightly and sustainably on the earth? Will we muddle our way to ecotopia by incremental change driven by things like high gas prices at the pump, or is a more radical rethinking needed? Are we about to embark on a green technological revolution that will not just save the planet but make life more pleasant? Or are we facing apocalypse as our consumptive sins catch up? What *is* the ideal Northwest life?

One hopes the beleaguered animals do not worry about this, but that means we have to do the worrying for them—that one of the purposes of *our* life has to become the preservation of *all* life.

The Pacific Northwest has seen some heartening success stories. Bald eagles, once rare, are now common. Grizzly bears and wolves are making comebacks under protection. There have been small successes in restoring stream fish populations, and many of the stream blockages of the past are being undone. Compared to many parts of the world, Northwest states have a high percentage of land in public ownership. The federal government alone still controls 69 percent of Alaska, 53 percent of Oregon, 50 percent of Idaho and 30 percent of Washington. As a result there is room here to sustain historic ecosystems in ways impossible in the East.

Government land management is just part of the story. Land preservation and conservation action has moved during the past several decades from the dramatic mountain peaks and empty rangelands to the beaches, creeks, sloughs, woods, pastures, and foothills near where most people live. Neighborhood by neighborhood, we've quietly become more ambitious in planning in hopes of protecting them for plants and animals. We want our great-grandchildren to experience the same Northwest we did.

But again, we're in a race between preservation and good intentions versus that press of five hundred newcomers a day. Even as factory and sewage

outfalls into Puget Sound or the Willamette River have been cleaned, more pollution washes in from the parking lots, roofs, lawns, and pets of an expanding population. Air particulates rain into mountain lakes. Oyster beds are closed because of fecal bacteria from livestock and failed septic systems. The pesticides that create perfect fruit also result in orchards without a hum of insect or bird life.

Wild salmon runs remain severely depressed. Orca whales are threatened by pollutants, a spotty food supply, and our whale-watching enthusiasms. The spotted owl continues to decline, in part because of an invasion of eastern barred owls. Parts of the ecosystem are on life support, and it's unclear yet whether, in the long run, they'll make it.

So is there any reason for hope?

One could argue that pessimism is not an option. Our species can't survive without a healthy planet, so this is not a battle we can choose to lose. Optimism is the only attitude that makes sense, because despair is self-fulfilling.

Fortunately, nature herself is our biggest cheerleader for this fundamental challenge of the twenty-first century. Anyone discouraged by the challenges needs to get out of the office once in a while and take heart from urban bays that are getting cleaner, urban rivers that are running clearer, and scenic vistas that are not as hazy as they were a decade or two ago. Nature rebounds in any corner when given a chance; the slow recovery of the slopes around Mount Saint Helens have been a splendid laboratory to prove that. Our knowledge of how the world works, while still very imperfect, is far ahead of where it was when the environmental movement began. A lot of smart people are trying to solve these problems. A lot of caring people are contributing in their own lives, their neighborhoods, and their communities.

This art exhibit is one small part of what someday may be seen as a global revolution, a renaissance, in environmental consciousness and behavior. As awful as we wise, wise humans can be to nature and to each other, we also seem to have an infinite capacity to learn and change.

So let yourself be intrigued, provoked, offended, delighted, and soothed by the paintings and sculptures you see here. And then take inspiration from this art to go out and make a difference.

ARTIST STATEMENTS

RICK BARTOW

OREGON

For the Plains it was the buffalo, for us all up and down the coast it was and still is the Salmon. In *Salmon Prayer* man and fish are created in old-growth cedar root, a species which will show in its DNA signs of salmon, in its makeup, up to a hundred miles from the sea—probably eagle delivered the fish.

> Hebwalah malshuk! Kil rrou `wuraghu `muk
> Hello, Salmon! You are my relative.
> – Wiyot language –

This piece is a story about interconnectedness and dependence on good water, abundant and clean for now and for future generations.

(right)
Salmon Chant, 1995
Soft pastel and graphite on paper
50.5 x 36.5
Collection of the Hallie Ford Museum of Art, Willamette University, Salem Oregon, Elmer Young Purchase Fund, YNGAF95.01.

(below)
Salmon Prayer, 2002
Carved cedar root, acrylic paint, and abalone shell
16 x 76 x 6
Collection of the Hallie Ford Museum of Art, Willamette University, Salem, Oregon, purchased with an endowment gift from the Confederated Tribes of Grand Ronde, through their Spirit Mountain Community Fund, 2002.053.

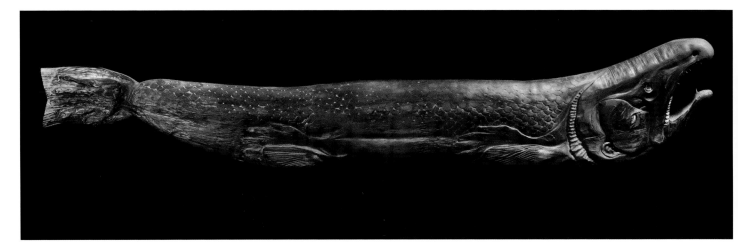

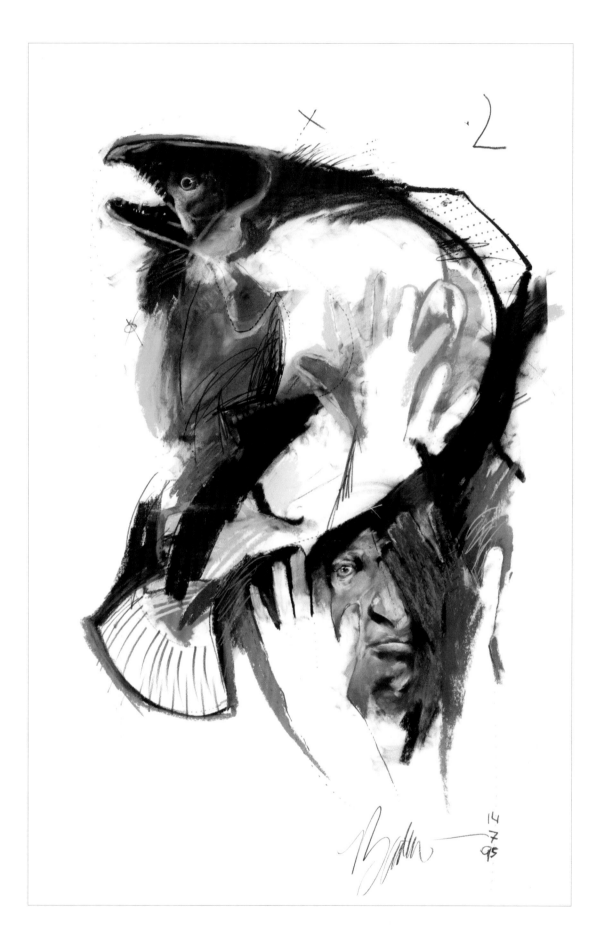

VAUGHN BELL

WASHINGTON

The installation *Village Green*, originally commissioned by the Massachusetts Museum of Contemporary Art, consists of "personal biospheres," each of which is an acrylic structure with a landscape contained inside that is composed of native plants indigenous to the landscape where the piece is installed. Viewers place their heads inside the biospheres, becoming part of the landscape and being immersed in the smells and up-close views of the plants, soil, and tiny creatures inside the biosphere. Referencing the idea of a village green, the common green space at the center of the traditional New England town, the piece re-situates the bucolic landscape within plastic. The distant view of the natural landscape is brought into the gallery, while also giving the viewer newfound intimacy with the land.

For the installation in the Northwest, *Village Green* becomes emblematic of the lush forests of the Pacific Northwest. The plants inside include mosses, native ferns, and low-light native plants such as wood sorrel *Oxalis oregana*.

Village Green drew from ideas developed in the Personal Biospheres series. This series began with a "Portable Personal Biosphere," a wearable headpiece to take a green horizon with you everywhere, and developed into "Personal Home Biospheres" that you could have in your home to bring the landscape inside. Explaining the "Personal Biospheres," I wrote:

> Many people long for the smells of nature and softness of greenery while living amidst concrete and diesel fumes. The Portable Personal Biosphere and Personal Home Biosphere are the answer for anyone who feels the ill effects of urban living. With these devices you can have the smells of nature with you everywhere. Whether in your home or walking the street, you will have the sensation that you are looking out over a green horizon.

The Personal Biospheres are not maintenance-free. As with any biosphere, attention must be maintained in order to ensure that proper levels of moisture and fresh air are available. With time, the wearer can adapt the personal biosphere to his or her own personal needs by adding to or changing the ecosystem within. Various ecosystems can exist within the personal biosphere, from prairie to forest to flower garden.

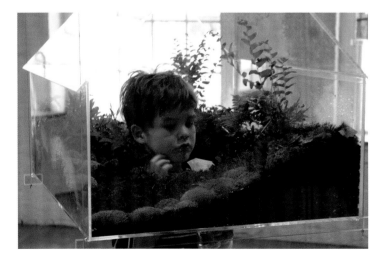

Village Green, 2008
Three glass biospheres
27 x 42 x 26
Courtesy of the artist, Seattle.

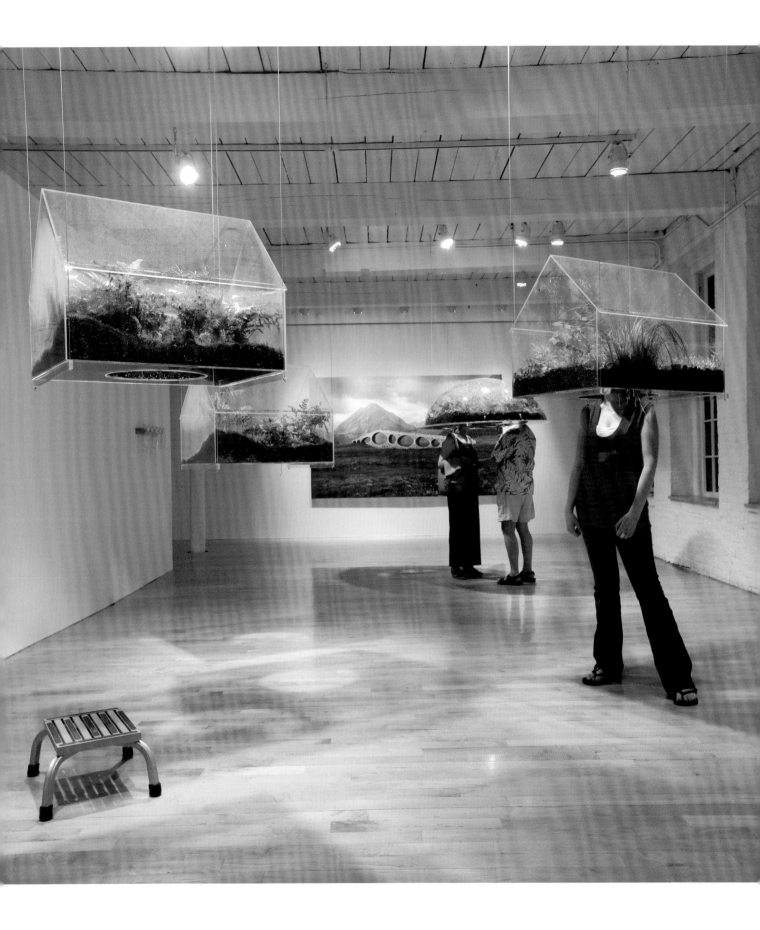

MARGARETHA BOOTSMA

BRITISH COLUMBIA

Water has long captured human imagination, bestowed restoration, and seemed infinite, boundless—a potent force. In these images, photography is melded with paint to explore what once was unimaginable: water's vulnerability to current political agendas, pollution, industrial waste, and human recklessness.

To the indiscriminating person, the destructive effect of urban sprawl and industry on our environment remains unnoticed. In *Limited Vision*, we notice first that traffic signage is placed unexpectedly in an apparently serene shoreline. This arouses the unsettling suspicion that human complicity with car culture cannot be ignored. On the periphery of the

image the viewer begins to recognize industrial structures that were not initially apparent but are seen only after careful observation. This is similar to the experience of being in a place for a while before one notices all of its details and, in this case, the significance of their presence altogether.

In *Construction II*, an industrial structure looms ominously close to a beach setting where there is human recreation. The figures at the shore appear to be oblivious of its presence. Here again industry remains on the periphery of consciousness where it is mistaken as being benign and irrelevant to one's daily activities.

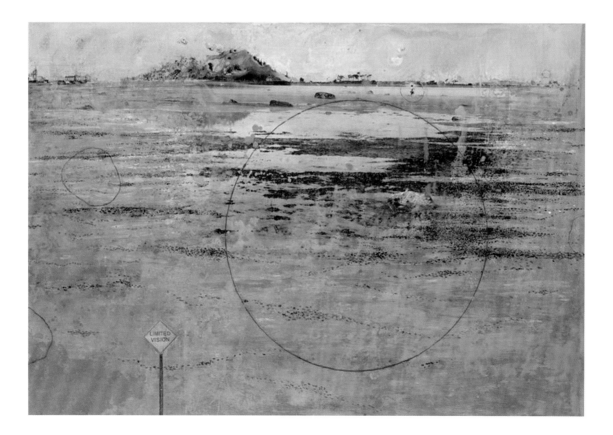

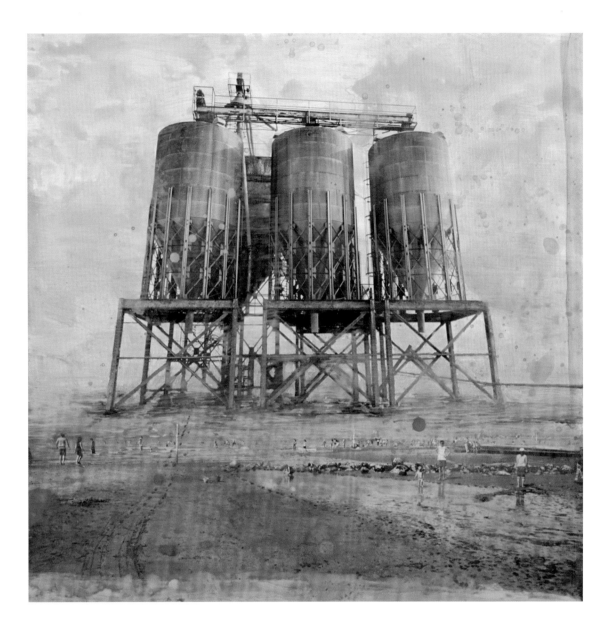

(left)
Limited Vision, 2007
Mixed media on panel
34 x 50
Courtesy of Linda Hodges Gallery,
Seattle.

(above)
Construction II, 2009
Mixed media on panel
24 x 24
Courtesy of Linda Hodges Gallery,
Seattle.

MICHAEL BROPHY

OREGON

My paintings of the late twentieth century and the first few years of the new millennium are a cumulative portrait of the Pacific Northwest region: its environment, landscape, history, and people. I paint how human encounters with the landscape have shaped the region, both visually and metaphorically.

The west is a constructed landscape, made from land use and resource extraction, but also stories, memories, histories, and depictions. Humans have always been a part of the land. They've always shaped the view. The Columbia River Valley that looks like a park was created by Native American brush burnings, and the intact stretch of river exists because of a nuclear superfund site. I've also come to think of the landscape as a character, with its own agency pushing back against us.

Of course, the act of painting is a construction, too. I strive to paint without sentiment. I'm painting the monuments in reverse, what's left in the wake of expansion. The Romans had coliseums. In the West, we have clear-cut hillsides, uniform replants, superfund sites, stumps and high-voltage power lines.

These landscapes may seem broken and the view spoiled, but space is still infinitely generous. I'm trying to paint my time.

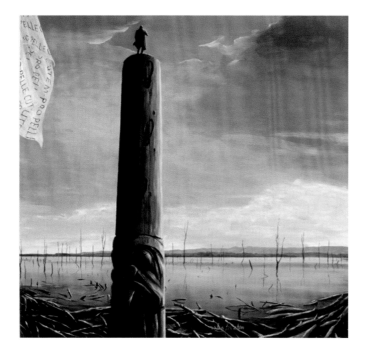

(left)
Beaver Trade, 2002
Oil on canvas
78 x 83.5.
Collection of the Boise Art Museum
Collectors Forum Purchase

(right)
Tree Curtain, 2004
Oil on canvas
54.75 x 44.25
Collection of the Hallie Ford Museum of Art, Willamette University, Salem, Oregon, Maribeth Collins Art Acquisition Fund, 2005.009.002.

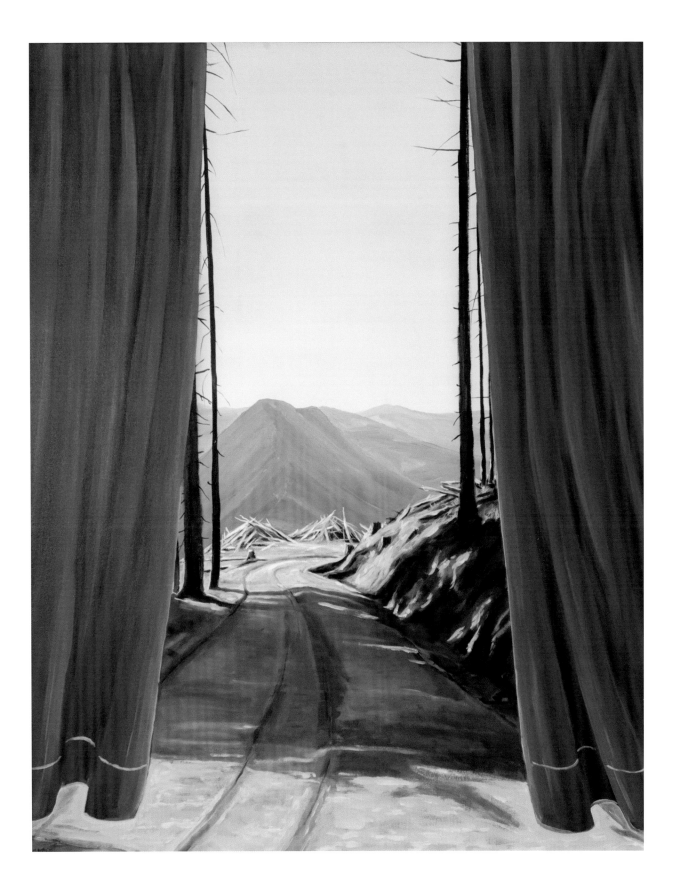

CYNTHIA CAMLIN

WASHINGTON

The works on paper in the Extremities series incorporate naturalistic detail with an invented vocabulary of abstract, crystallized forms and pooling watercolors to build images of melting icebergs. The icebergs are psychological metaphors expanded by the catastrophe of global warming into emblems of collapse. Their monstrous depths are alternatively hidden and revealed in an imagined process of transformation.

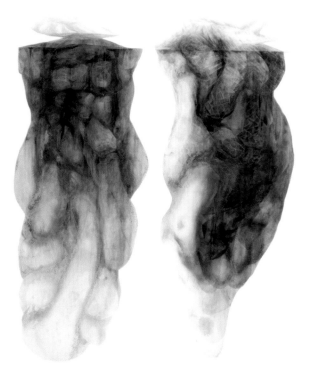

From the Extremities series

(left)
Melted #5, 2008
Watercolor, ink, and acrylic
60 x 52
Courtesy of the artist, Bellingham.

(right)
Melted #10, 2008
Watercolor, ink and acrylic
60 x 52
Courtesy of the artist, Bellingham.

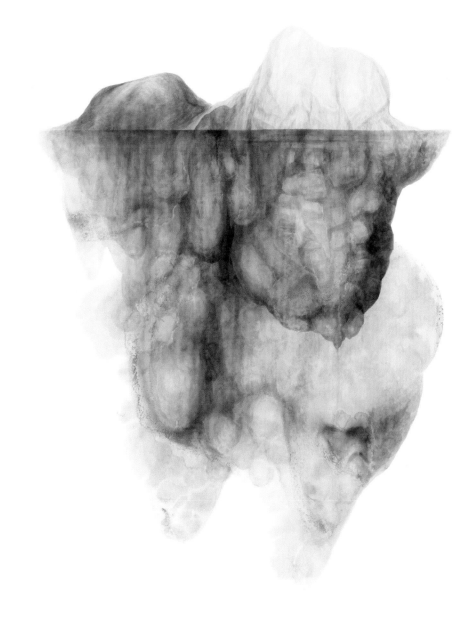

STEVE DAVIS

WASHINGTON

Beauty can lurk in strange places, and I find myself drawn to landscapes that suggest ambiguity, emptiness, and the spiritually untidy. To me, they resonate as backdrops to stories and dreams—vague suggestions of the earth as a temporary gesture. They are as close to nowhere as I can get.

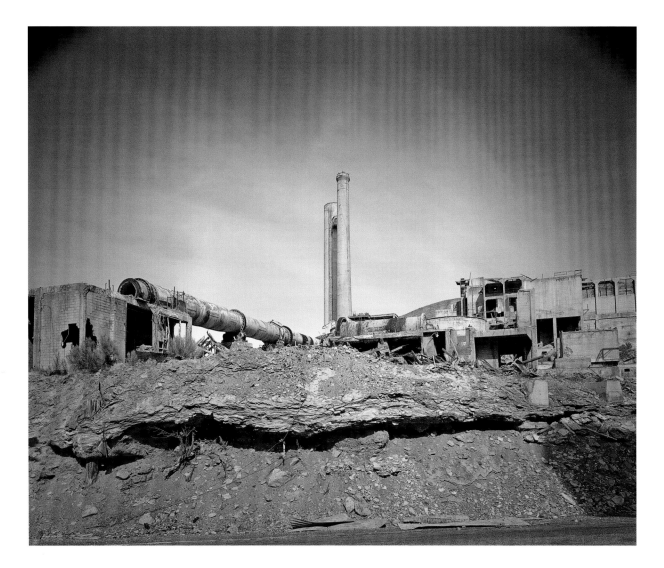

Lime, Oregon (The Western Lands series), 2007–09
Archival inkjet print
40 x 50
Courtesy of James Harris Gallery, Seattle.

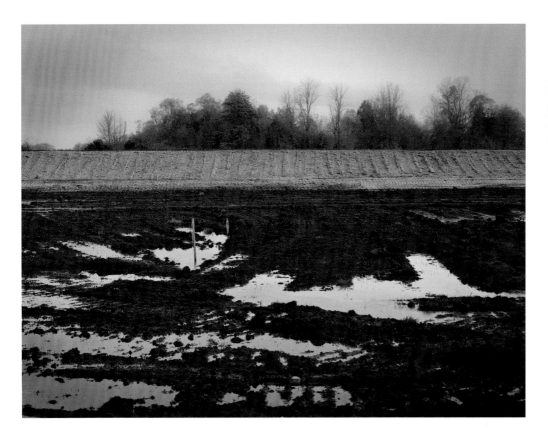

Nisqually (The Western Lands series), 2008
Archival inkjet print
22.5 x 28
Courtesy of James Harris Gallery, Seattle.

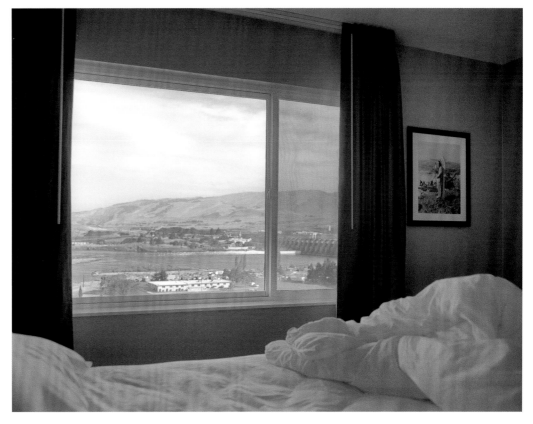

John Day Dam, 2009
Archival inkjet print
22.5 x 28
Courtesy of James Harris Gallery, Seattle.

JANA DEMARTINI

OREGON

Nature is my strongest source of inspiration. That's why I am sensitive to the neglectful, often downright arrogant and irresponsible behavior of our species. I am dealing with the confrontation of modern technical advances in construction with the disappearing of the natural landscape. The trigger this time was the obliteration of a nursery in Beaverton by a sea of row houses. It was shocking. Being trained as a painter and also a printmaker I have often combined both disciplines in my exhibits with the paintings being usually the predominant ones. This time I feel that prints are more appropriate for my message. The angularity of the construction machines lends itself better to prints. I first made a lot of sketches and studies of the various machines, which were not difficult to find. They are everywhere around us, even in my native Prague, which was another shocker. I am at once intrigued by the machines' angular, masculine shapes and repulsed by the way they change the landscape into a grey, hard, cement and asphalt desert, out of human proportions. And all that in the name of progress?

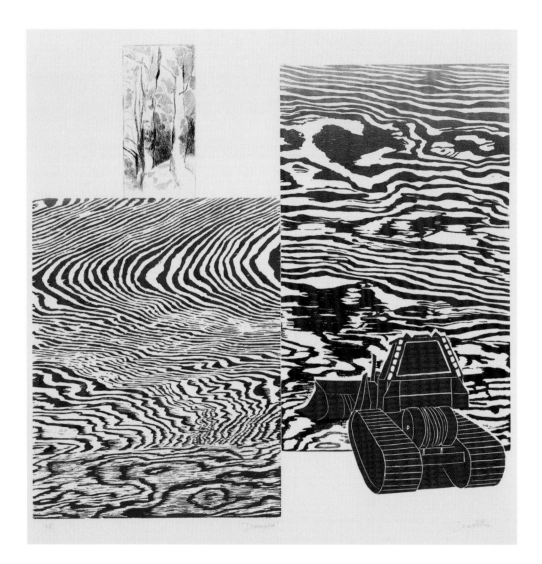

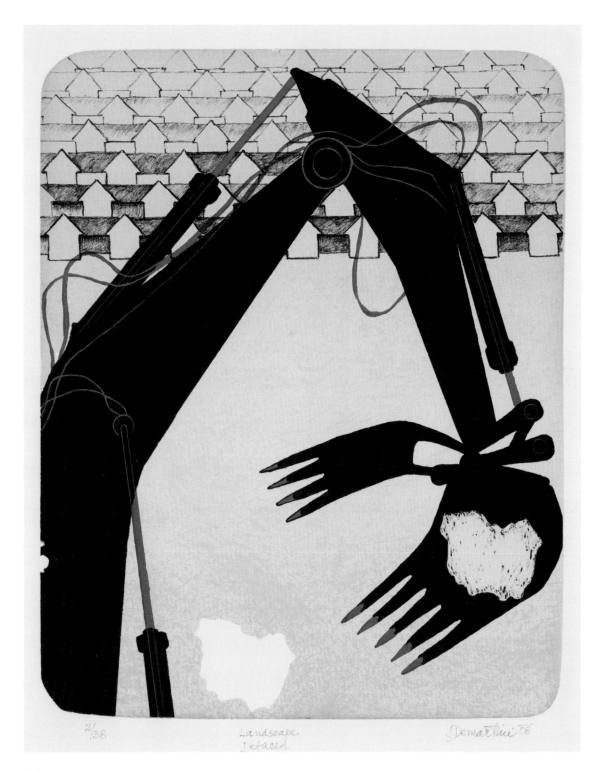

2/38 Landscape Defaced Demartini 08

(left)
Disrupted, 2008
Etching, woodcut, and linocut
20.75 x 21.5
Courtesy of Blackfish Gallery,
Portland.

(above)
Landscape Defaced, 2008
Lithograph
12 x 9.5
Courtesy of Blackfish Gallery,
Portland

LANNY DEVUONO

WASHINGTON

These four works are part of a larger series of over eighty small boxes titled *American Short Stories*. I had long used landscape imagery as a visual metaphor for our desire to contain what cannot be contained, a way of examining the tension that exists between ownership and freedom. What we see limitless and expansive, we want to possess; what we love, we want to tame; where we find beauty, we try to ascribe purpose.

I choose the landscape of the Inland Northwest because it is where I live and it is beautiful. These pieces are an homage both to that beauty and to our complex human reactions to it—reactions that are filled with unequal parts of splendor, ridiculousness, and pathos.

From the Series American Short Stories

(left)
American Short Stories #5, 2002
Oil on wood
6 x 6 x 5
Courtesy of the artist, Spokane.

(above)
American Short Stories #7, 2002
Oil on wood
6 x 6 x 2
Courtesy of the artist, Spokane.

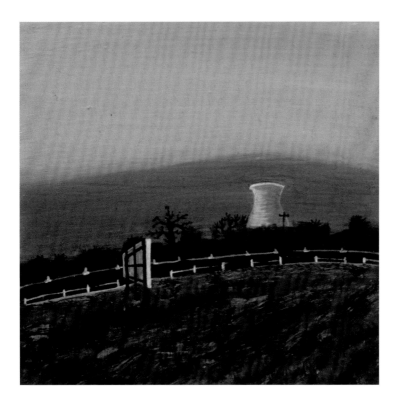

American Short Stories #35, 2004
Oil on wood
6 x 6 x 3
Courtesy of the artist, Spokane.

American Short Stories #40, 2004
Oil on wood
6 x 6 x 5
Courtesy of the artist, Spokane.

ROBERT DOZONO

OREGON

I grew up in the world when no one wasted anything. I had one pair of shoes and when they wore out my father and I went to a store and bought another pair of canvas tennis shoes. I grew up in the world where no one used paper or plastic bags. Everyone wrapped everything in newspaper: fish, vegetables, everything. Nothing was wasted.

No trash was in the street because everything was reused. Cans were reused to make toys or other useful items. I used them to play kick the can with my friends or tied strings to them to walk with, making sounds like a loud horse. I made airplanes, kites, and fishing poles using bamboo we cut. I caught bugs for bait using layers of spider webs on a wire ring tied to a long bamboo pole.

I have had no regular garbage service for over seventeen years. Once or twice a year I have garbage picked up of items that I cannot recycle, compost, or put into my paintings. I shred all yard debris and put it back to earth. In those seventeen years, I've been recycling my own garbage into my paintings. Nowadays I am happier because I can recycle more items at the curbside pickup and I don't need to collect as much garbage in my studio.

I still feel uncomfortable for having too many shoes, shirts, cars, and too much fishing equipment. I have a difficult time throwing things away.

I think we don't respect or take enough responsibility for our natural environment. In this age and our economy, it is almost impossible not to waste. I almost wish that we could return to a time where no one wasted, and people reused everything.

The natural environment is very important to me. All these years I have reused objects that one cannot recycle—plastic items without number, wiper blades, rubber bands, toothpaste tubes, hair dryers, etc.—into my work. I still fish with my friends. The rivers and their unfortunate interaction with humans are evident to me when my friends and I fish. We often carry out garbage others have left. Many of my paintings are large river scenes of the Clackamas River and other areas of Oregon. I attempt to bring to the foreground what we are doing to our natural resources by using a canvas layered with what is normally cast aside.

Jumbo Veggie Dog, Upper Clackamas #10, 2005
Oil, garbage on canvas
60 x 54
Courtesy of Blackfish Gallery, Portland.

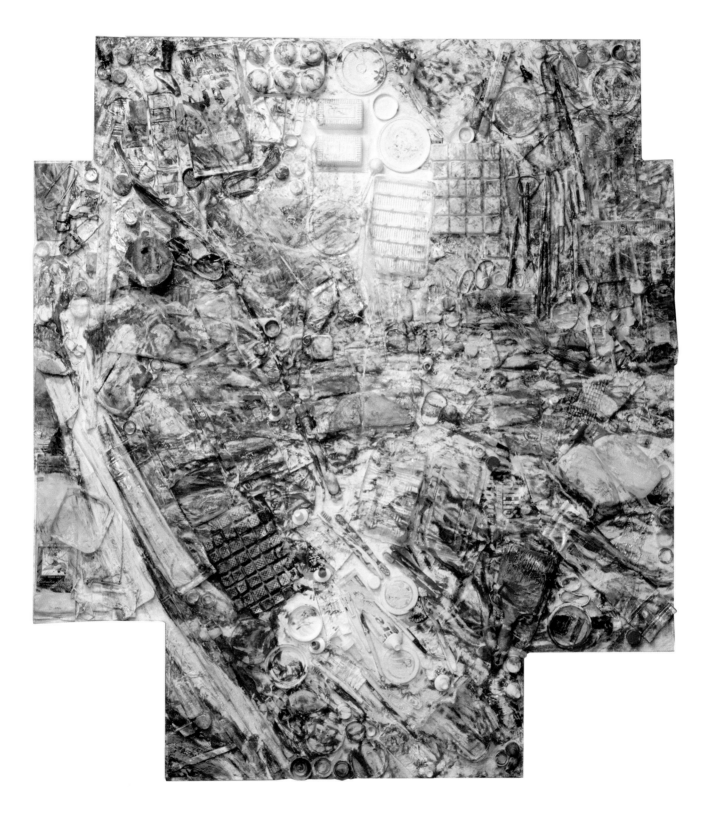

PHILIP GOVEDARE

WASHINGTON

My current landscape paintings are derived from sites that are both visually compelling and charged with implications of use, development, and ownership. The conditions of the landscape, including light, color, texture, and atmosphere, give meaning to place. The transformation of land and sky through industry and enterprise may be deliberate, or simply the unintended consequence of the human impact on a fragile environment. My work is both a response to and an interpretation of the world, but it also imparts sentiment through projection that comes from a perspective of anxiety about the condition of landscape and nature in our world today. I endeavor to create a fictional response to an observed phenomenon, a metaphor that is infused with a blend of celebration, uncertainty, and doubt about our place in the natural world. In this manner, this work may allude to the past and simultaneously project into the future. My paintings are a response to the landscape we inhabit, with all its complexity and layered meanings.

Excavation # 3, 2009
Oil on canvas
44 x 78
Courtesy of the artist and Francine Seders Gallery, Seattle.

Flood, 2009
Oil on canvas
59 x 55
Courtesy of the artist and Francine
Seders Gallery, Seattle.

JOHN GRADE

WASHINGTON

Collector was initially designed to fit precisely into a specific gap within a slot canyon in a remote area of Utah's Escalante Plateau. Floodwaters surge through these canyons each year in late summer. By siting the sculpture in this flood route, I wondered if the water would completely destroy my work, leave it in broken pieces, or just scour it clean. Prior to wedging it into the canyon, I anchored *Collector* in Willapa Bay on the Washington coast for sixteen months. I wanted the sculpture to remain under the water until the oysters that grew on it were large enough to eat. To balance my intention for the piece with an element of chance or vulnerability, I loosely floated the sculpture within a net of yellow webbing that could potentially wear through and release the sculpture from its anchor. A "hundred year storm" hit the bay that winter, and though it

failed to break loose the sculpture, it tore all of the brown seaweed from the sculpture's surface. This muted seaweed was eventually replaced by a different species of bright, grass-green seaweed that grew in a kind of halo around the sculpture—it was the only place in the bay where this new variety of seaweed took hold. After removing the sculpture and harvesting its oysters, I bolted the wet sculpture with its mane of crustaceans and seaweed to the front of my truck so that it would frame my view like blinders as I drove south to Utah. The sculpture's surface dried, and flakes of it dispersed, before accumulating a crust of dead black bugs and ochre dust on the way to the canyon. In the end it was not the desert flooding that washed the sculpture of its remaining barnacles, clams, and vestiges of seaweed; it was wrens that picked it clean.

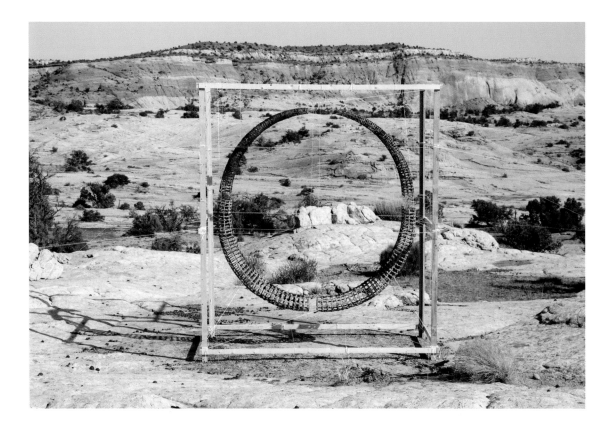

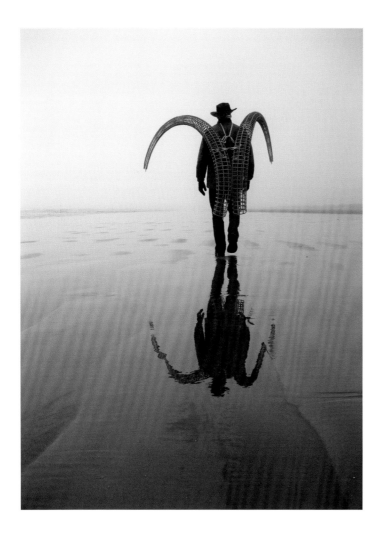

(opposite page)
Collector, 2007
Wood
72 x 78 x 8
Courtesy of Davidson Galleries,
Seattle.

(left)
Collector, 2006-08
C-print mounted to Dibond, Ed. 5
24 x 36
Courtesy of the artist and
Davidson Galleries, Seattle.

(below)
Collector: Willapa Bay, Washington, 2006-08
C-print mounted to Dibond, Ed. 3
24 x 36
Courtesy of the artist and
Davidson Galleries, Seattle.

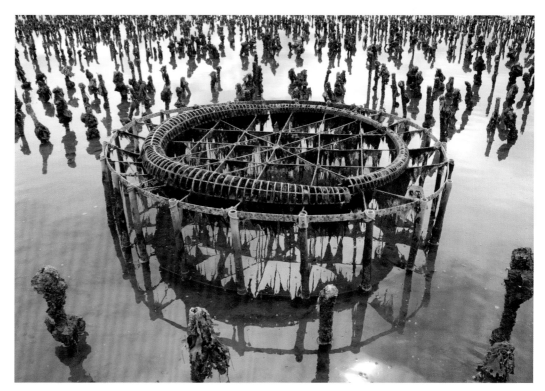

ROLL HARDY

OREGON

Much of my work explores the specter of Oregon's weathered industrial streets and buildings and the region's abandoned factories and sites. These areas fascinate me with all their worn surfaces, broken concrete, and bold shapes. Each site-specific place is one in which the processes of decay and reassimilation are evident. The Earth swallows up the floors, water and wind expose and scatter the edges, and new life collapses the sides. The interior spaces I find serve up an array of discarded items and surprises left behind by former inhabitants that invoke strange, mysterious stories.

The sense of mystery and danger keeps me looking around each new corner, opening the next door or walking down that furthest street. The scenes I depict often portray a feeling that anything may or has occurred there, where lawlessness has taken root. These places seem an appropriate metaphor for a certain emptiness found in the human heart.

Sometimes, this sense of place functions in an archeological way, representing the skeletons of our economic past and the chance of a brighter future. By attending to places whose very nature is one of neglect, I aim to present a different view, where mystery and possibility thrive and change can take hold. I question what role these spaces serve in our culture now and how the individual relates to them in our own search for meaning and understanding. I leave the viewer to define such places independently.

(opposite page)
Hazy Afternoon, 2008
Oil on canvas
11.25 x 24.25
Courtesy of Laura Russo Gallery,
Portland.

(above)
Uphill Battle, 2008
Oil on canvas
10 x 23
Collection of Ron Kloepfer,
Portland.

JAN HOPKINS

WASHINGTON

I am inspired by native basket-weavers who gather from nature, and process and make baskets. Restrictions to protect against the overharvest of traditional materials have led me to seek out alternative resources. After years of experimenting with various leaves, peels, and pods, I feel my work celebrates nature and its bounty. I work with materials that I can easily attain, gather, and process in abundance without doing harm to the natural world.

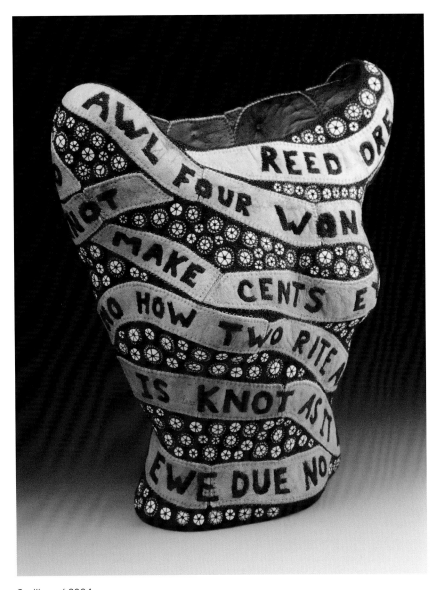

Spellbound, 2004
Grapefruit peels, waxed linen,
hemp paper, and ostrich shell
beads
18 x 16 x 9
Courtesy of the artist, Everett.

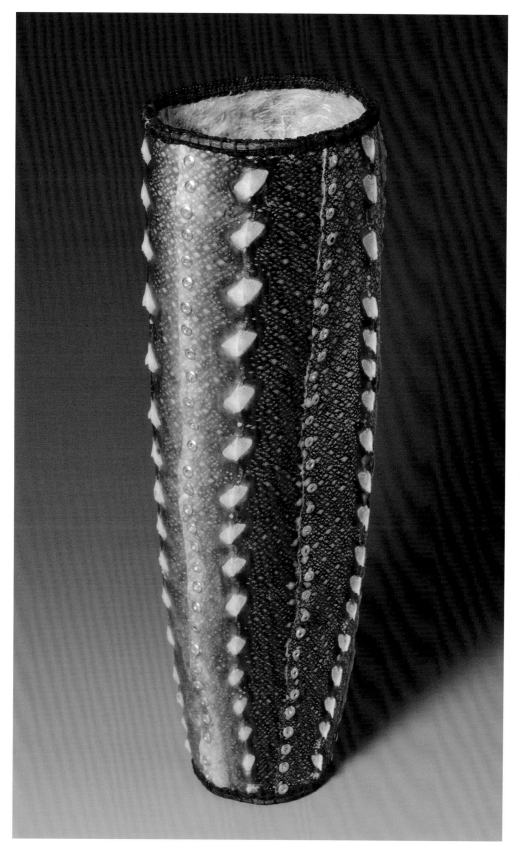

Sturgeon Vessel, 2007
Sturgeon skin, ostrich shell
beads, waxed linen, and paper
15 x 5 x 5
Collection of Danielle Bodine,
Clinton.

CHRIS JORDAN

WASHINGTON

The series Running the Numbers: An American Self-Portrait looks at contemporary American culture through the austere lens of statistics. Each image portrays a specific quantity of something: fifteen million sheets of office paper (five minutes of paper use); 106,000 aluminum cans (thirty seconds of can consumption), and so on. My hope is that images representing these quantities might have a different effect than the raw numbers alone, such as we find daily in articles and books. Statistics can feel abstract and anesthetizing, making it difficult to connect with and make meaning of 3.6 million SUV sales in one year, for example, or 2.3 million Americans in prison, or 32,000 breast augmentation surgeries in the United States every month.

This project visually examines these vast and bizarre measures of our society, in large, intricately detailed prints assembled from thousands of smaller photographs. Employing themes such as the near versus the far, and the one versus the many, I hope to raise some questions about the roles and responsibilities we each play as individuals in a collective that is increasingly enormous, incomprehensible, and overwhelming.

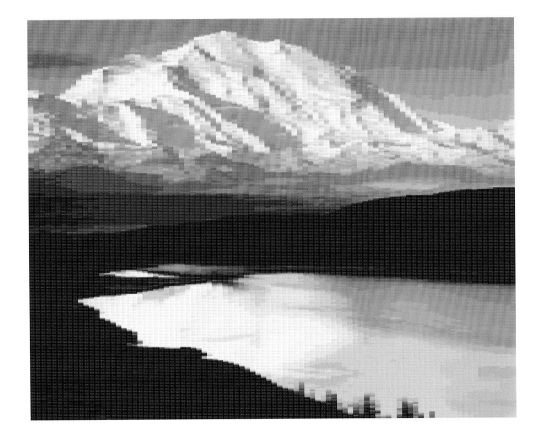

From the series Running the Numbers: An American Self-Portrait

(opposite page)
Denali Denial, 2006
Pigmented ink-jet print
60 x 99
Courtesy of the artist, Seattle; and
Kopeikin Gallery, Los Angeles.

(above)
Plastic Bottles, 2007
Pigmented ink-jet print
60 x 120
Courtesy of the artist, Seattle; and
Kopeikin Gallery, Los Angeles.

(right)
Plastic Bottles (detail), 2007

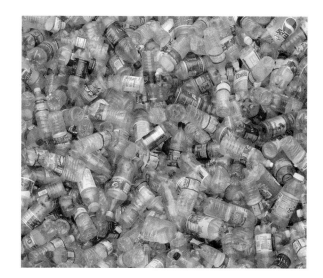

CRAIG LANGAGER

WASHINGTON

The theme of the landscape first occurred in my paintings and then my sculpture. In New York City during the eighties, I produced sculptural works with various combinations and fragments of animal, landscape, and architectural images, often in a tableau format. All of these works were characterized by a strong sense of narrative time sensed through the expansive space of the installations, elementary forms and color, and silent movement. Some installations deepened and mystified the space through reflective surfaces such as large pools of actual water, metal, glass and mirrors, and through elaborate architectural structures. Various works commented on the physical exhaustion of natural resources through man's manipulations (chemical pollutions, cloning, and governmental exploitation). While these works primarily focused on the animal as a surrogate or a device to recall human attitudes and behavior, I also combined human and animal forms.

Back in the Northwest in the nineties, I continued to be involved with themes of environmental ex- ploitation, such as exhaustion of our national park system and political propaganda. I also began to re-focus on the bird as an image. In the eighties I used the raven as the cautionary messenger and sentry for public apathy and greed. In the nineties the visual element of more color came to the foreground when I became interested in the extinction of songbirds. I was alarmed that estimates from Cornell University and Duke University stated that since 1960 we have lost approximately seventy-five percent of our songbird populations. Loss of habitat and pesticides are the two major causes.

Today, my lifetime interest in birds continues but my images are heightened with exaggeration of form, placement, and color due to the increase in biotechnological changes in the food chain, cloning, and societal increases in greed and rage. These bird works are visual equivalents for my experiences and fantasies in contemporary life. With humor, ironic comment, and/or enigmatic manner, I respond to various situations and questions relating to current issues in the environment.

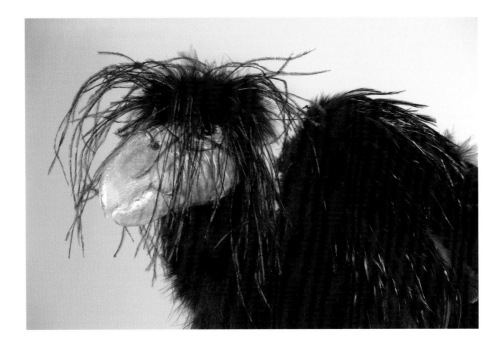

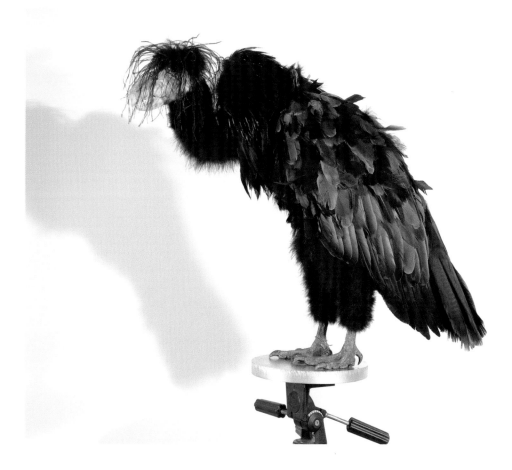

From the series Birds I Have
Known

(above)
*Tille, All Primped and Ready for
Wall Street* (detail), 2008
Poultry feathers, urethane, and
lobster claw
72 x34
Courtesy of the artist, Bellingham.

(right)
Bennie Cloned (detail), 2009
Poultry feathers, urethane, and
possum skull
78 x 22
Courtesy of the artist, Bellingham.

(opposite page)
*Tille, All Primped and Ready for
Wall Street* (detail), 2008

NANCY LOUGHLIN

WASHINGTON

Mankind has the capacity to damage the habitat and we are seeing signs of disruption in the natural world. Has mankind tipped the balance of nature? Can we pull back our need to expand and lessen our impact and damage to the environment? I am interested in nature's ability to reclaim old territory. My work is an attempt to visualize that process. I believe that nature will in time reclaim everything that we have built and treasured.

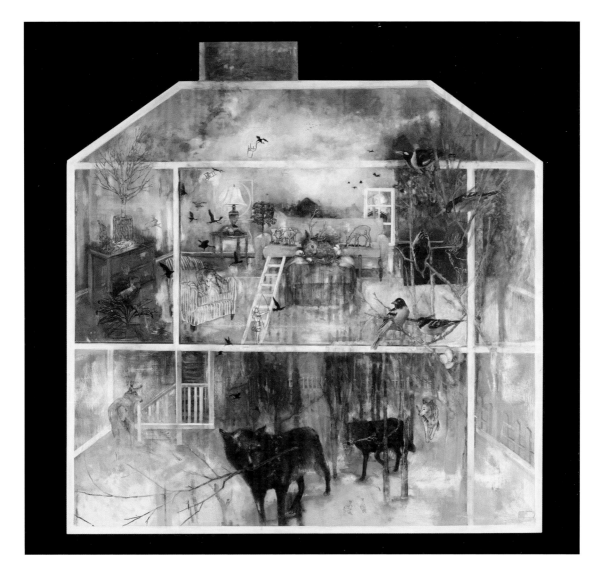

Reclamation, 2009
Oil on wood panel
44 x 44
Courtesy of Linda Hodges Gallery,
Seattle.

ROBERT McCAULEY

WASHINGTON

When rumors of the New World filtered back to Europe, heads were dazzled by conjured images of a pure, untouched Garden. Proof of God's existence. No place was more iconic than Niagara Falls. With settlements came the demystification of *God's Country*, a systematic east-to-west juggernaut, the mechanics of which included aggressive land demarcation via surveying, and the passive-aggressive proliferation of souvenirs as well as the photograph. With each snapshot, the transcendental became the tangible, measurable, and banal.

The progress of westward expansion was recorded in numerous American Romantic paintings by the depiction of a small column of smoke lazily drifting across a valley, signaling more acres being deforested for farming. Also in *The Leatherstocking Tales*, with Natty Bumpo peering out from the shadows of the wilderness and seeing his own life marginalized by the encroaching hinterland.

The American painters, commissioned by the railroads to romanticize even the most mundane landscapes from the East to the West Coast, not only created wanderlust satisfied by a ticket on the next train west, but also tapped into the transcendental and spiritual movements by ethereal depictions of rock-hard mountains.

At the end of the line (no pun intended), travelers stood under enormous groves of virgin forests. These were cathedrals, the trees their columns. If Americans were self-conscious of lacking Europe's culture borne of centuries of civilization, Nature would become the culture of the Americas. The ruins of David Caspar Friedrich had no more import than Bierstadt's redwood behemoths.

Out of this beginning, a dichotomy persists to our own time. Americans want to pursue their livelihood, which thrives on and decimates natural resources. But with wealth comes recreation time; time to enjoy the untouched wilderness. (A few years ago, a Jeep ad stated, "Jeep: it evens out that whole nature versus man thing.")

American Metaphor: Cultured Garden or Raging Wilderness, with its tagline: *when you go out in the woods today, you're in for a big surprise*, reminds us that we can't have it both ways. Clear-cut the timber, but don't expect the biodiversity of Eden, and don't mistake verdant farms of Doug fir for wilderness. Or leave it untouched, but think twice about building your dream home in a combustible natural resource. Ironically, in our time, the Bureau of Land Management considers unregulated naturally occurring wildfire as the only way to insure the longevity of forests.

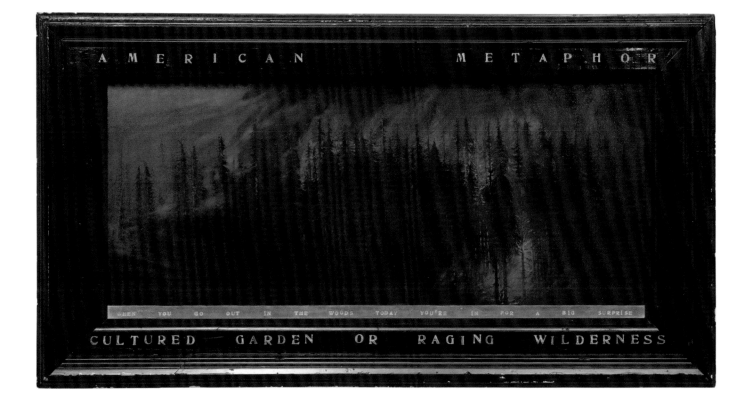

American Metaphor: Cultured
Garden or Raging Wilderness, 1997
Oil on canvas, with lead
40 x 74
Collection of John and Linda
Anderson, Rockford, Illinois.

ANNA McKEE

WASHINGTON

I search for visual patterns in environmental phenomena such as tree growth, soil strata, and volcanic formations to transform these patterns into narrative portraits of the land. The patterns speak of time and change. These stories emerge from a life-long interest in the natural sciences and human history. I am influenced by the naturalist tradition for its contemplative observation of the land.

Details in the land materialize as script. What language is being built within these layers of growth, accretion, and decay? The patterns speak of time and change. Though silent, these places are the physical embodiment of past environmental events, human and otherwise.

My current project is focused on ice cores and glaciers. The ice is a metaphor for the deep memory of the world and both the frailty and strength of its ecosystems. Ice offers symbolic stories of the planet and our effect on that story through millennia.

These are some of the first prints from this effort. The patterns in the prints come from several sources, including high-resolution photographs, ice-penetrating radar, and my own drawings of ice cores and glaciers.

(opposite page)
Ice Sounding/At the Divide, 2009
Etching, chine colle
8 x 8
Courtesy of the artist and Francine
Seders Gallery, Seattle.

(above)
Memory–Easton Glacier, 2009
Etching, chine colle
8 x 8
Courtesy of the artist and Francine
Seders Gallery, Seattle.

LAURA McPHEE

IDAHO

My new body of photographic work, River of No Return, presents queries about our contemporary notion of the utopian American landscape—what it was and what it will become. This series examines conflicting ideas about landscape in America, and scrutinizes our values and beliefs about the natural world. The nature/culture dilemma is endlessly complex, and my work describes this kaleidoscopic, fragmented, and contested relationship, within one place and among one group of people in the remote Sawtooth Mountains of central Idaho. The relationship between the tiny population there and the natural world in which they are immersed reflects, in microcosm, the same issues of ideology we face in America at large.

Over the past few years, I have assembled a sequence of photographs that engages the large-scale canvasses of the past while picturing a future none of the early landscape painters or nineteenth-century survey photographers could have envisioned. In these photographs the viewer gets both the distant ideal and the proximate reality. Viewers of these photographs become owners of a landscape photographed across many seasons, as if it were their space. They stand intermediate between the photographer and the subjects of portraiture, engaging myriad characters who inhabit the valley:

ranchers, scavengers, scientists, landowners, and children. Inhabiting country where no one else seems to exist, they look to the horizon and find that space feels both endless in its vastness and improbably contained by fragile fences and futile lines of demarcation.

The photographs look at our attempts to hold on to the past, to reclaim what we have lost or destroyed: To which historical ideal of ecological balance are we seeking to return? Where human survival depends on the relationship between humans and animals, the photographs ask how well we coexist. The images follow many strands of history—miners following explorers, ranchers coming to feed the miners. Now the landscape seems populated by recreational tourists. It is also dotted with scientists, who serve as historians and measurers, tinkering with the future, attempting to save the past. They intermingle with scavengers and fortune seekers who eke out a living collecting and selling the valley's natural resources.

No American is without a notion of what the West looks like and what it represents. The myth of a big open space where you can live out your dreams rests like an escape hatch in our collective imagination.

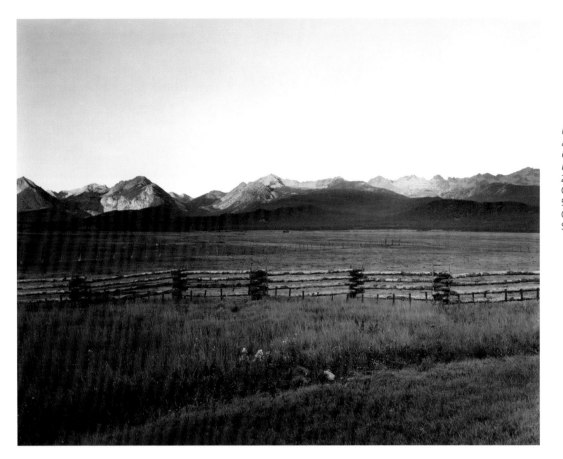

*Red Fladry to Spook Wolves
and Deter Them from Killing
Calves, Fourth of July Creek
Ranch, Custer County, Idaho,*
2003
Chromogenic print
50 x 60, Ed. 5
Courtesy G. Gibson Gallery,
Seattle.

*Understory Flareups, Fourth
of July Creek, Valley Road
Wildfire, Custer County, Idaho
(River of No Return),* 2005
Chromogenic print
50 x 60
Courtesy G. Gibson Gallery,
Seattle.

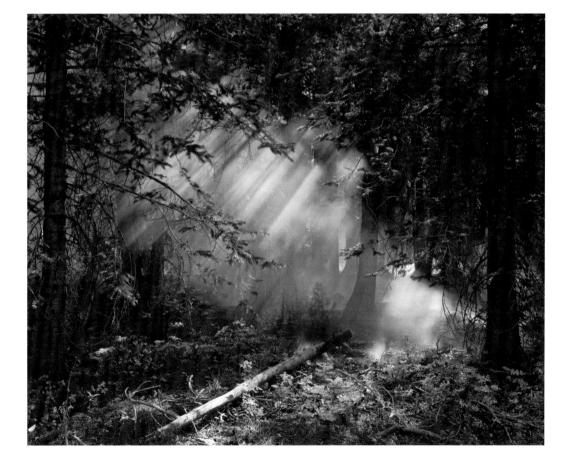

SUSAN ROBB

WASHINGTON

Using De Maria's Lightning Rods The Animals Stage A Valiant Surrender.
As the title suggests, this piece imagines a scenario wherein, fed up with humankind, animals have claimed an element from Walter De Maria's *Lightning Field* of 1977 and repurposed it to support a surrender flag fashioned from their own feathers, hides, and fur. The crystalline "rocks," fabricated from colored and mirrored acrylic, suggest a future nature that has been supplanted altogether by the man-made. The flag, violently thrust into this pile not only articulates ecological crisis as an assault, but further evokes the iconic image *Raising the Flag Over Iwo Jima*, conjoining a narrative of triumph and destruction.

Signal Transduction Knowledge Environment.
Signal transduction is the means plants use to exchange information about their environment so they can make any necessary changes or adaptations. This piece is an imagined amplification of that communication and an attempt to bring us into their dialogue. With its heavily layered and processed whispering four-channel audio track repeating, "It's in the air. It's in the water," it endeavors to makes visible that which for us is imperceptible.

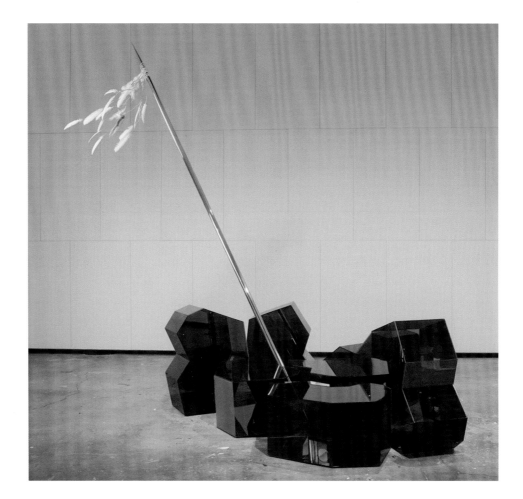

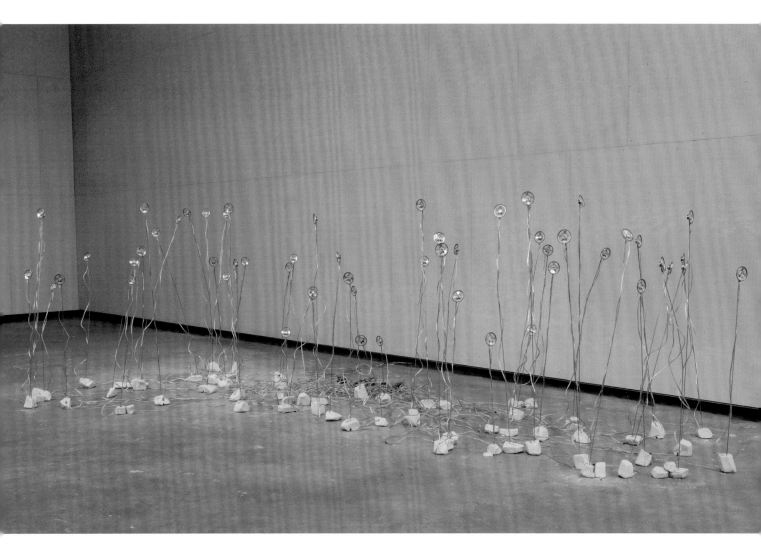

(left)
Using De Maria's Lighting Rod,
The Animals Stage A Valiant
Surrender, 2008
Mixed media
12 x 96 x 96
Courtesy of the artist, Seattle.

(above)
Signal Transduction Knowledge
Environment, 2006
Four-channel audio, clay,
speakers, and wire
48 x 180 x 48
Courtesy of the artist, Seattle.

KAREN RUDD

WASHINGTON

In 2005, I was awarded an artist fellowship to participate in an archeological dig in western Washington. With a group of scientists, artists, and volunteers, I helped excavate a former homestead belonging to a Sauk-Suiattle tribe woman, her Norwegian immigrant husband, and their children. Because of the fast rate of decay in the damp woods of the Pacific Northwest, the excavation site had few stable landmarks, with the notable exception of the enormous old-growth cedar stumps. For a week, I helped locate, measure, and map these ancient stumps that ranged from ten to eighteeen feet in diameter, with a few reaching nearly twice that size.

Since this influential experience, my art has focused on tree stumps and, most often, recreating the form from reclaimed corrugated cardboard boxes. Not only am I reconstructing the organic form from its original material, but I am drawing connections between past and present by creating a historical subject in a ubiquitous and contemporary material. These sculptures, like much of my work, are a commentary on consumerism and natural resource use.

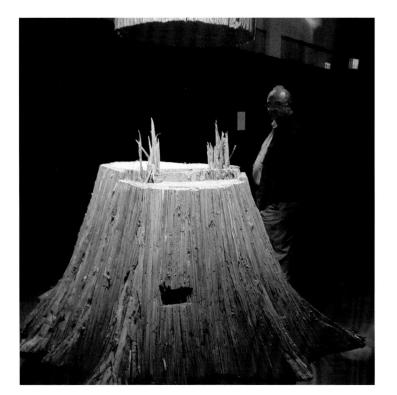

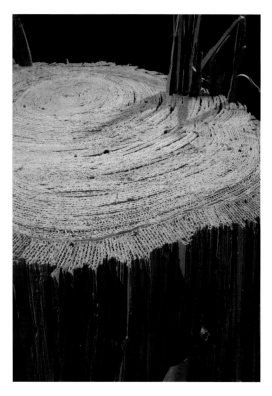

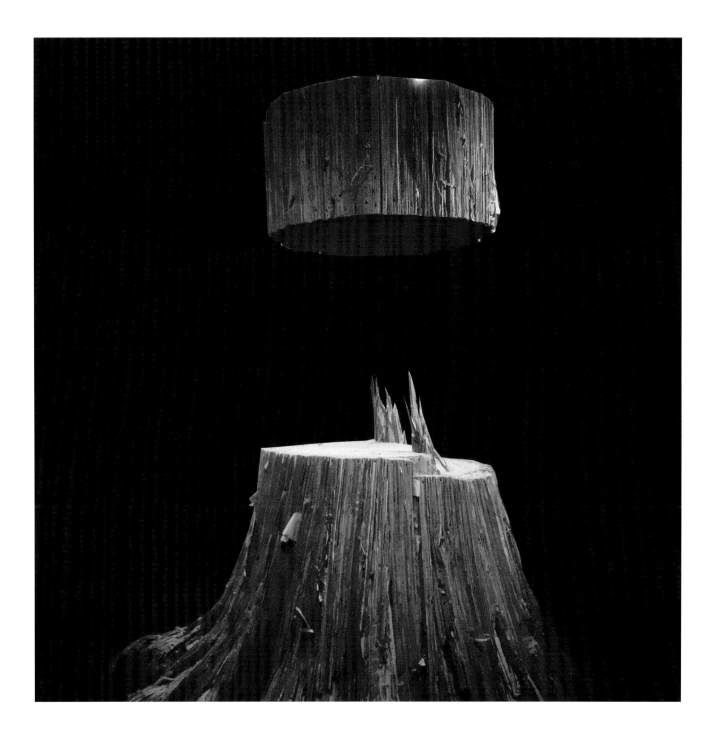

(above and left)
Last Stand: Cedar (details), 2008
Recycled cardboard
Lower section: 48.5 x 98 x 96;
upper section 18 x 30 x 30
Courtesy of the artist, Seattle.

MARK RUWEDEL

CALIFORNIA

In 1992 and 1993 I made three trips down the Columbia River through the Hanford Reservation. While most of the Columbia is a series of placid lakes behind dams, at Hanford the river is free-flowing, looking much as it did in previous times; however, it is plutonium production that has prohibited any other development of the site, not conservation or preservation. Here, secrecy and security trumped hydrology. I was struck by the paradox of this landscape: its beauty and its horror, the radical difference between what it looked like and why it looked that that, and what those differences might mean.

When I made the photographs that became *The Hanford Stretch*, I had in mind those wonderful nineteenth-century albums documenting the ancient ruins along the Nile. I wanted to produce a post-atomic version of the Valley of Kings and to suggest that landscapes have acquired new meanings in the nuclear age. It is no small irony that, since my modest voyages on the river, the Hanford Reach has been officially designated as "Wild and Scenic."

"Instead of listening to the silence, we have shouted into the void." (Wallace Stegner)

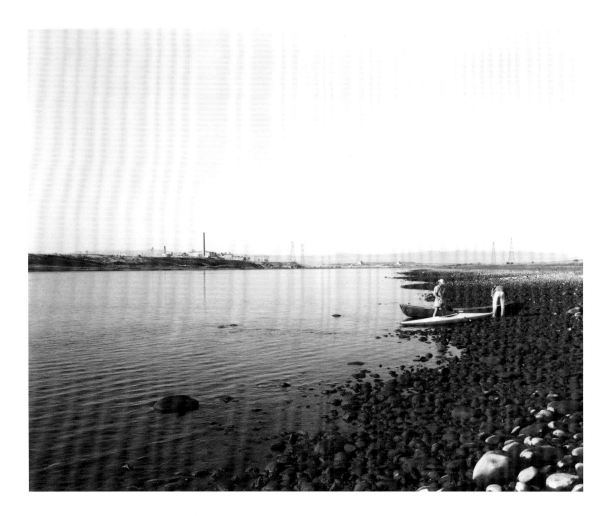

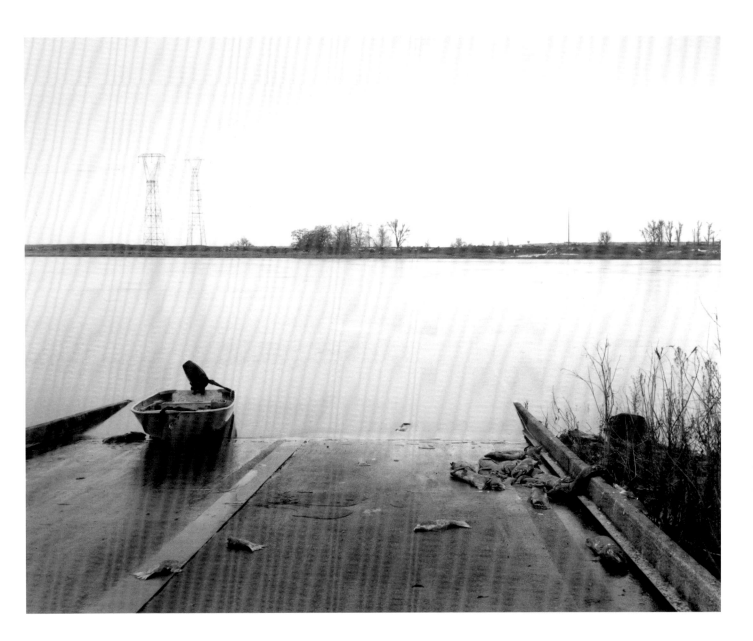

(left)
*The Hanford Stretch: 100KW and
KE Areas (Breaking Camp, Early
Morning)*, 1992-93
Silver print mounted on board with
text in pencil
24 x 28 overall
Courtesy of the artist and Gallery
Luisotti, Santa Monica.

(above)
*The Hanford Stretch: East White
Bluffs Ferry Site (Steve's
Boat/Dead Chinook)*, 1992-93
Silver print mounted on board
with text in pencil
24 x 28 overall
Courtesy of the artist and Gallery
Luisotti, Santa Monica.

MATT SELLARS

WASHINGTON

We live in a time of shifting identities within the regions we call home. This is especially true in the Pacific Northwest where many of the local economies were founded and prospered by resource extraction. While examples of this raw past still serve to sell salmon in grocery stores and an outdoorsy lifestyle to the outside world, the fact is that economies in the Northwest have had to adapt to a changing environment. When we look back to the late nineteenth and early twentieth centuries we see an era of vast natural resource richness. It was at once a time of low-hanging fruit while also being one of extreme ecological naïveté. In any case this abundance came to form the identity of this region. Its raw and wild environs shaped the way that people came to view themselves. In essence, this approach was creating a multiple-generations-long understanding of itself while depleting the ingredients of its own existence.

I chose to name this piece after a large geographical region on the Arabian Peninsula called the Rub' al Khali, which is Arabic for "Empty Quarter." It is an area of sand desert covering roughly 250,000 square miles that is devoid of conspicuous signs of life. The Bedouins live around the edges, but the last interior settlements and trade routes disappeared in 300 AD due to desertification. In early 2008 I wanted to do a piece that dealt with the evidence that scientists were starting to discover that shallow coastal zones of the North Pacific Ocean were becoming devoid of life. These dead zones were occurring because of low to zero oxygen levels in the water, brought on, it is thought, by high surface winds that move the oxygen-rich waters further out and allow the deeper cold waters to seep in. A water version of the Empty Quarter was being created where abundant life thrived before.

I carved five boats that were based on fishing trawlers from the early twentieth century that would sit on a flat surface, leaning over on their keels. For me the boat is a symbol of what is ingenious about the human spirit. It is a crossroads of beauty and design that comes together to support man in his most hazardous explorations. It is a symbol of his overarching desire to set out for unknown waters and search for improvement there. When I see a boat sitting hove-to in the mud, it is like a negation of all those lofty principles. It is an image of a tool that has fallen into disuse due to circumstances outside of the individual's control. I decided to place the boats on a table surface that has triangular holes in it that appear at once like abstracted waves and at another glance like windows into an empty void below it, one that for me represents a sea devoid of life.

(opposite page)
Empty Quarter (details), 2008
Poplar, paint, and stain
45 x 73 x 93
Courtesy of Platform Gallery, Seattle.

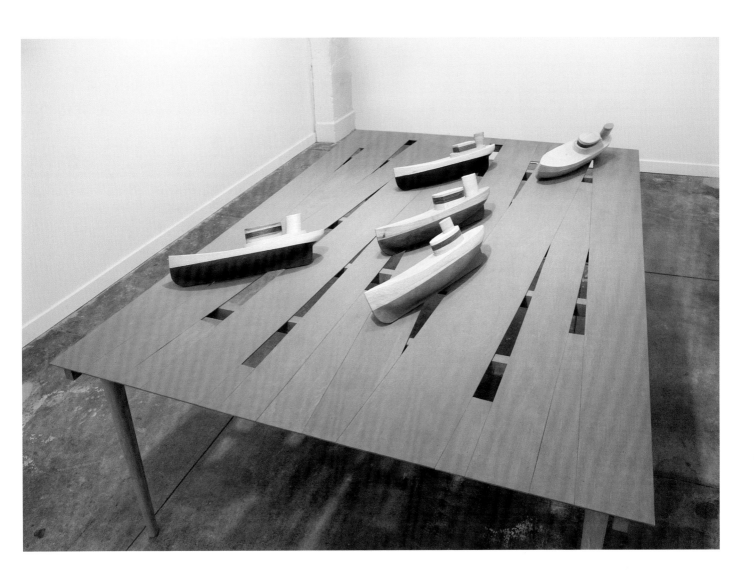

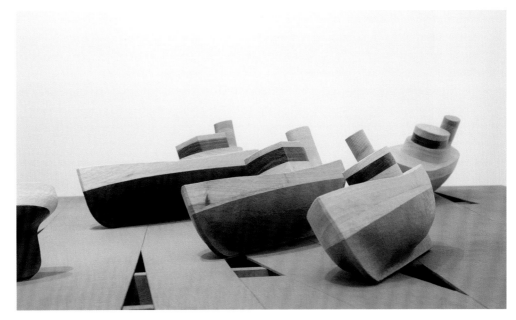

BUSTER SIMPSON

WASHINGTON

Walla Walla Campanile: Instrument Implement, completed in 2008, is a sculpture measuring twenty-five and a half feet high that is located in front of the William A. Grant Water & Environmental Center at Walla Walla Community College. The Water & Environmental Center is designed as a common-ground meeting place, to collectively garner consensus for the sake of a healthy watershed and the next seven generations. Art often serves as a catalyst to that consensus process and that is the intent of the Walla Walla Campanile.

In 2006, the Washington State Art Commission, in partnership with the Washington State Department of Corrections and the Walla Walla Community College, funded this public art project. Initially, a working title, *Walla Walla Bound*, was developed to compare shared conditions of penal incarceration with that of salmon imprisoned in a concrete channel of Mill Creek in downtown Walla Walla. A series of Poetic License plates, locally written and then stamped at the Walla Walla Penitentiary license plate facility, provided a literal telling of the story that informs *Walla Walla Campanile: Instrument Implement*. *Poetic License* is now part of a public discourse along Mill Creek in the effort to retrofit dysfunctional sections of Mill Creek with riparian habitat.

The sculpture, as *Instrument*, marks the passage of time as well as heralding the environmental conditions of the Walla Walla watershed. As *Implement*, the discs that once worked the local loess soils have been transformed into a campanile, which when combined with an ensemble of additional elements embellishes the sculpture as allegory.

The tintinnabulation, or ringing, of the campanile is set by computer to the time of day, to a traditional change-ringing peal, to compositions based on the eight-disc "chance scale," and responds to the ongoing scientific data stream rhythms gleaned from the

Walla Walla watershed. The campanile includes sixty-one carbon-steel harrow discs. The top eight are framed with a brass bell yoke and can be pneumatically rung when triggered by a computer signal. The remaining discs can be rung manually. The profile of the fifteen-foot-high structure of harrow discs is based on a bell profile, which, when repeated, resembles a sonic wave sign.

As in change-ringing, the sonic peal responds to the data stream, tolling the health of the watershed and the return of the salmon. The salmon is the "canary in the coal mine," a living indicator of the condition of the watershed. A triptych sculptural assemblage, consisting of a cast-bronze female salmon (coated canary yellow) placed in a cage/net and balanced on a solid glass salmon egg, suggests that the salmon is our "canary," indicating the health of our ecosystem and, in particular, the Walla Walla watershed.

The campanile is supported by a structure mimicking the power transmission towers crisscrossing eastern Washington that transport hydroelectric power. The structure inverts at the top into an antenna tower suggesting a tepee. The tower armature also supports a double-sided framed panel with glass-laminated photovoltaic cells facing south, and, on the reverse side, an image of McNary Dam. During the day the solar cells cast their shadows onto the translucent image of the dam. Both the dam image and solar array are backlit at night.

The sculpture rests on a plinth serving as a footing. The side surfaces of the pedestal present cast-concrete impressions taken from license plates stamped at the penitentiary in Walla Walla. These Poetic License impressions include: on the east side, "WALLA WALLA CAMPANILE INSTRUMENT IMPLEMENT 2008"; on the north side, "DISCS HERALD THE WATERSHED PEAL OF CHANGE RINGING"; on the west side, a poem by WWCC professor Jennifer Boyden,

"WATER IS LODGE TO WHAT IS DIS LODGED"; and on the south side, "BOUND TO BE," by Hillela Simpson.

The sculpture is sited near Titus Creek and adjacent to the trail from the main campus to the Water & Environmental Center. Titus Creek flows past the Campanile and on to Mill Creek, which then flows into the Walla Walla River and on to the Columbia River. At the confluence of Titus and Mill Creek, a two-sided screen supporting 288 stamped aluminum license plates made at the Walla Walla Penitentiary provides a poetic discourse to the project. One side presents poetry by writers who live within the watershed. The poets are Jennifer Boyden, Janice King, Dan Lamberton, and Katrina

Roberts. The other side is a scientific habitat assessment for Mill Creek, which I appropriated and altered the text, titling the work *Field and Stream with Fish*. The plates have a reflective color background, creating a color field. Eventually a series of Poetic License pieces will find their way along the environmentally imprisoned sections of Mill Creek.

The realization of the *Instrument Implement* project is the result of the efforts of many citizens, artists, organizations, companies, governmental entities, and tribal members, including the support of the Washington State Arts Commission in partnership with Washington State Department of Corrections and Walla Walla Community College.

Stills from the DVD of Walla Walla Campanile: Instrument Implement,
2008
Courtesy of the artist, Seattle.
Video production: Star Sutherland

ADAM SORENSON

OREGON

Images of the natural world in art history have always stood for something more than scenery. Awe and banality, nostalgia and mystery, and narrative all have a place. The themes that exist below the surface are what drive my work. As humanity continues to reshape the environment it exists in, what we see and how we see it is reshaped as well. Both art history and contemporary culture act as filters that landscape painting is created and viewed through.

Romantic painting in the nineteenth century is a huge influence on my work. The embellishment and exaggeration of those pictures are what interest me the most. Making a mountain abnormally large, or a storm incredibly destructive, become examples of humanity within the backdrop of nature.

In *Hideout* (2009), the viewer is surrounded by imposing rock walls and picturesque falling water. The weight and gravity of the rock and water is intended to overwhelm, and implies that one has happened upon this place alone and by accident. By combining what feels natural in the fog and water and rock with color that is so completely unnatural, I invite the viewer to look intently with both awe and uncertainty. The composition and skeleton of the painting create the grandeur that a place like that in the natural world would command, yet the subjects within and the color and pattern that decorate them challenge the nature that inspired it.

Banks I (2009) is a liberal misuse of color, formed into the banks of a winding river. Rocks rendered in multiple patterns and color pile up on the banks of an artificial pink river, much in the same way sediment is carried and collected. The challenge in this piece was to allow the obviously fake elements to act and react in much the same way as their natural counterparts do, yet have them remain entirely artificial. Despite the staged elements of this scene, they still behave in a way that is entirely natural.

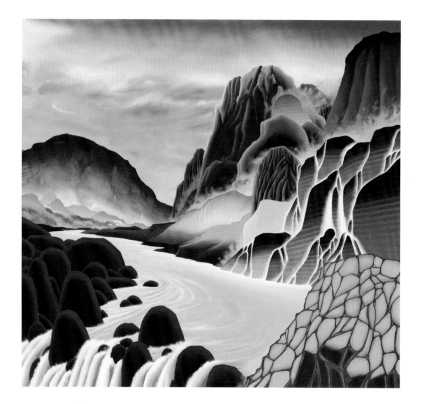

(left)
Banks I, 2009
Oil on linen
40 x 44
Courtesy of James Harris Gallery, Seattle.

(right)
Hide Out, 2009
Oil on linen
64 x 47
Courtesy of James Harris Gallery, Seattle

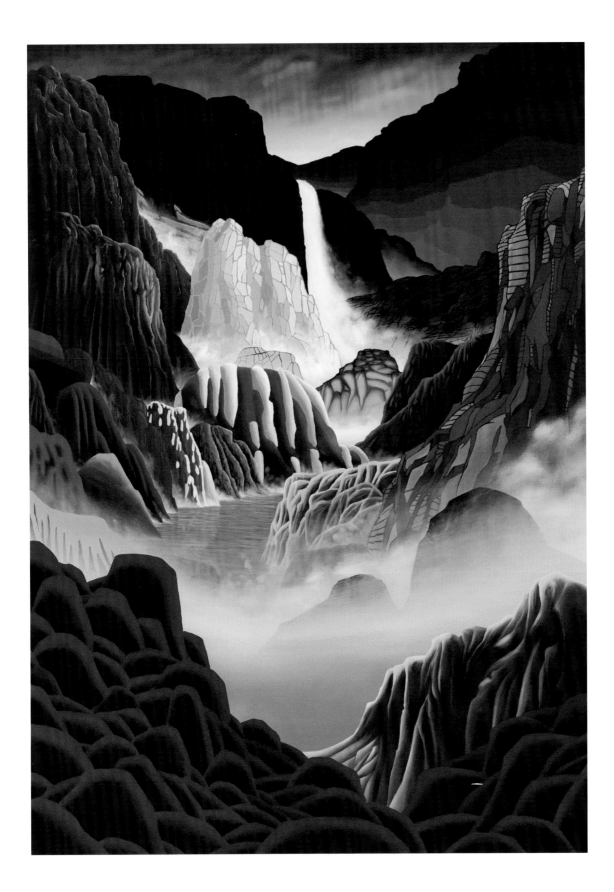

JAMES B. THOMPSON

OREGON

The American West has always figured prominently as a potent mythological symbol in our collective cultural consciousness. Yet a radical transformation of this region of the country is well under way as projected developments erode the natural landscape, the urban growth boundaries of metropolitan areas expand into the surrounding farmland, and land-use issues pit corporate interests against the individual citizens who once stood in stark contrast to their natural surroundings while admitting an uneasy alliance with the sparse and majestic landscape they call home. *The Vanishing Landscape* project is a series of abstract paintings and prints I am creating that deals specifically with the vanishing iconic landscape that still nostalgically characterizes both Americans and the American experience as it continues to permeate the contemporary popular media, literature, and culture.

It is important to address this conceit in the realm of visual art because it will subsequently reflect our cultural concerns in a medium known for celebrating the reality of our shared visual, sensory, and intuitive responses to these obvious changes in our individual and collective experiences of the surrounding landscape. There exists an established tradition for landscape painting, but this genre offers only a pictorial representation or appearance of the landscape itself and does not adequately depict its disappearance, transformation, nor the changes currently being wrought upon our immediate environment as planned developments, agribusiness, and even golf resorts replace small-town life, rural communities, family farms, and forests. When the actual landscape vanishes, I am compelled as a visual artist to examine more fully the symbolic mythology of the West as its dynamic also undergoes a radical shift in the cultural zeitgeist through this displacement.

It is the rapid, technological changes to the landscape and then what remains in spirit that I am interested in capturing in painted form—not grain elevators. The method of rendering abstract paintings and prints is a celebration of the very act of change, since this creative process involves the kind of continual mark-making that generates new sets of problems on the surface of each piece. Creating abstract art allows for the latitude necessary to address this concept of the vanishing iconic landscape while mirroring the very qualities of spirit that inhabitants of this region possess in terms of capability, skillfulness, adaptability, and commitment as they become active participants in the re-creation of the new West and its inherent mythology.

(top left)
Furrows, 2006
Intaglio and mixed media on paper
21.25 x 21.25
Collection of the Hallie Ford Museum of Art, Willamette University, Salem, Oregon, Maribeth Collins Art Acquisition Fund, 2006.024.002.

(bottom left)
Liminal, 2009
Intaglio and mixed media on paper
21 x 21
Courtesy of the artist, Salem.

(top right)
Subaqueous, 2009
Intaglio and mixed media on paper
21 x 21
Courtesy of the artist, Salem.

(bottom right)
Talus, 2009
Intaglio and mixed media on paper
21 x 21
Courtesy of the artist, Salem.

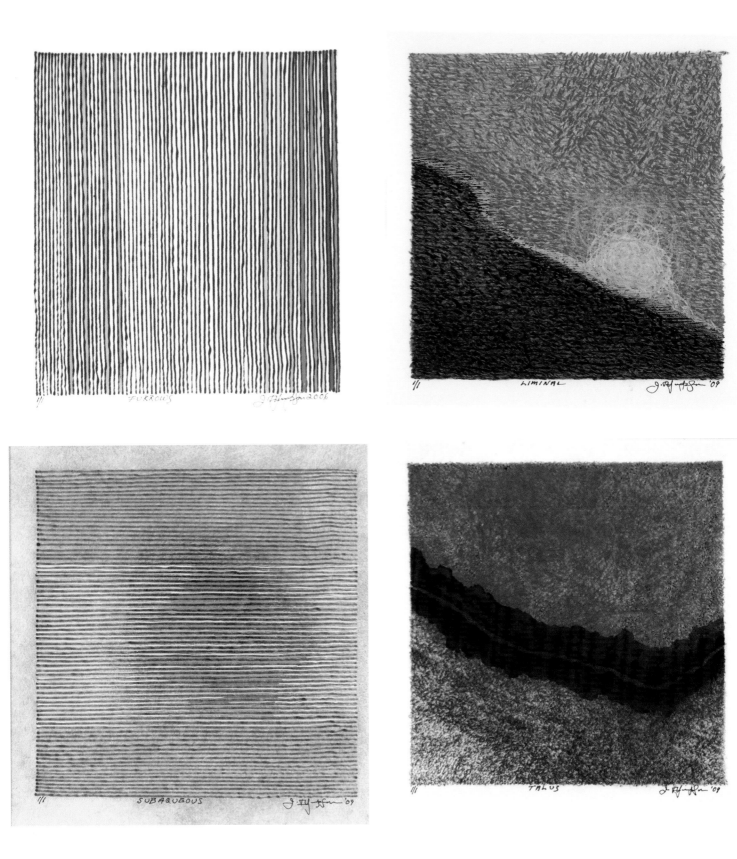

1/1 FURROWS

1/1 LIMINAL

1/1 SUBAQUEOUS

1/1 TALUS

(All measurements in inches, height x width x depth)

RICK BARTOW (Oregon)

Salmon Chant, 1995
Soft pastel and graphite on paper
50.5 x 36.5
Collection of the Hallie Ford Museum of
Art, Willamette University, Salem
Oregon, Elmer Young Purchase Fund,
YNGAF95.01.

Salmon Prayer, 2002
Carved cedar root, acrylic paint, and
abalone shell
16 x 76 x 6
Collection of the Hallie Ford Museum
of Art, Willamette University, Salem,
Oregon, purchased with an endowment
gift from the Confederated Tribes of
Grand Ronde, through their Spirit
Mountain Community Fund, 2002.053.

VAUGHN BELL (Washington)

Village Green, 2008
Three glass biospheres
27 x 42 x 26
Courtesy of the artist, Seattle.

MARGARETHA BOOTSMA (British
Columbia)

Limited Vision, 2007
Mixed media on panel
34 x 50
Courtesy of Linda Hodges Gallery,
Seattle.

Construction II, 2009
Mixed media on panel
24 x 24
Courtesy of Linda Hodges Gallery,
Seattle.

MICHAEL BROPHY (Oregon)

Beaver Trade, 2002
Oil on canvas
78 x 83.5.
Collection of the Boise Art Museum
Collectors Forum Purchase

Tree Curtain, 2004
Oil on canvas
54.75 x 44.25
Collection of the Hallie Ford Museum of
Art, Willamette University, Salem,
Oregon, Maribeth Collins Art Acquisition
Fund, 2005.009.002.

Blowdown, 2007
Oil on canvas
74 x 80
Collection of Bill Driscoll and Lisa
Hoffman, Tacoma, Washington

CYNTHIA CAMLIN (Washington)
From the Extremities series

Melted #5, 2008
Watercolor, ink, and acrylic
60 x 52
Courtesy of the artist, Bellingham.

Melted # 6, 2008
Watercolor, ink, and acrylic
60 x 52
Courtesy of the artist, Bellingham.

Melted #10, 2008
Watercolor, ink and acrylic
60 x 52
Courtesy of the artist, Bellingham.

STEVE DAVIS (Washington)

Lime, Oregon (The Western Lands
series), 2007-09
Archival inkjet print
40 x 50
Courtesy of James Harris Gallery,
Seattle.

Nisqually (The Western Lands series),
2008
Archival inkjet print
22.5 x 28
Courtesy of James Harris Gallery,
Seattle.

John Day Dam, 2009
Archival inkjet print
22.5 x 28
Courtesy of James Harris Gallery,
Seattle.

JANA DEMARTINI (Oregon)

Disrupted, 2008
Etching, woodcut, and linocut
20.75 x 21.5
Courtesy of Blackfish Gallery, Portland.

Landscape Defaced, 2008
Lithograph
12 x 9.5
Courtesy of Blackfish Gallery, Portland

LANNY DeVUONO (Washington)
From the series American Short Stories

American Short Stories #5, 2002
Oil on wood
6 x 6 x 5
Courtesy of the artist, Spokane.

American Short Stories #7, 2002
Oil on wood
6 x 6 x 2
Courtesy of the artist, Spokane.

American Short Stories #35, 2004
Oil on wood
6 x 6 x 3
Courtesy of the artist, Spokane.

American Short Stories #40, 2004
Oil on wood
6 x 6 x 5
Courtesy of the artist, Spokane.

ROBERT DOZONO (Oregon)

Jumbo Veggie Dog, Upper Clackamas #10, 2005
Oil and garbage on canvas
60 x 54
Courtesy of Blackfish Gallery, Portland.

PHILIP GOVEDARE (Washington)

Excavation # 3, 2009
Oil on canvas
44 x 78
Courtesy of the artist and Francine Seders Gallery, Seattle.

Flood, 2009
Oil on canvas
59 x 55
Courtesy of the artist and Francine Seders Gallery, Seattle.

JOHN GRADE (Washington)

Collector, 2007
Wood
72 x 78 x 8
Courtesy of Davidson Galleries, Seattle.

Collector, 2006–08
C-print mounted to Dibond, Ed. 5
24 x 36
Courtesy of the artist and Davidson Galleries, Seattle.

Collector: Willapa Bay, Washington, 2006–08
C-print mounted to Dibond, Ed. 3
24 x 36
Courtesy of the artist and Davidson Galleries, Seattle.

ROLL HARDY (Oregon)

Hazy Afternoon, 2008
Oil on canvas
11.25 x 24.25
Courtesy of Laura Russo Gallery, Portland.

Uphill Battle, 2008
Oil on canvas
10 x 23
Collection of Ron Kloepfer, Portland.

JAN HOPKINS (Washington)

Spellbound, 2004
Grapefruit peels, waxed linen, hemp paper, and ostrich shell beads
18 x 16 x 9
Courtesy of the artist, Everett.
Photo credit: Jerry McCollum

Sturgeon Vessel, 2007
Sturgeon skin, ostrich shell beads, waxed linen, and paper
15 x 5 x 5
Collection of Danielle Bodine, Clinton.

CHRIS JORDAN (Washington)
From the series Running the Numbers: An American Self-Portrait

Denali Denial, 2006
Pigmented ink-jet print
60 x 99
Courtesy of the artist, Seattle; and Kopeikin Gallery, Los Angeles.

Plastic Bottles, 2007
Pigmented ink-jet print
60 x 120
Courtesy of the artist, Seattle; and Kopeikin Gallery, Los Angeles.

CRAIG LANGAGER (Washington)
From the series Birds I Have Known

Tille, All Primped and Ready for Wall Street, 2008
Poultry feathers, urethane, and lobster claw
72 x 34
Courtesy of the artist, Bellingham.

Bennie Cloned, 2009
Poultry feathers, urethane, and possum skull
78 x 22
Courtesy of the artist, Bellingham.

NANCY LOUGHLIN (Washington)

Reclamation, 2009
Oil on wood panel
44 x 44
Courtesy of Linda Hodges Gallery, Seattle.

ROBERT McCAULEY (Washington)

American Metaphor: Cultured Garden or Raging Wilderness, 1997
Oil on canvas, with lead
40 x 74
Collection of John and Linda Anderson, Rockford, Illinois.

ANNA McKEE (Washington)

Ice Sounding/At the Divide, 2009
Etching, chine colle
8 x 8
Courtesy of the artist and Francine Seders Gallery, Seattle.

Memory—Easton Glacier, 2009
Etching, chine colle
8 x 8
Courtesy of the artist and Francine Seders Gallery, Seattle.

LAURA McPHEE (Idaho)

Red Fladry to Spook Wolves and Deter Them from Killing Calves, Fourth of July Creek Ranch, Custer County, Idaho, 2003
Chromogenic print
50 x 60, Ed. 5
Courtesy G. Gibson Gallery, Seattle.

Understory Flareups, Fourth of July Creek, Valley Road Wildfire, Custer County, Idaho (River of No Return), 2005
Chromogenic print
50 x 60
Courtesy G. Gibson Gallery, Seattle.

SUSAN ROBB (Washington)

Signal Transduction Knowledge Environment, 2006
Four-channel audio, clay, speakers, and wire
48 x 180 x 48
Courtesy of the artist, Seattle.

Using De Maria's Lighting Rod, The Animals Stage A Valiant Surrender, 2008
Mixed media
12 x 96 x 96
Courtesy of the artist, Seattle.

KAREN RUDD (Washington)

Last Stand: Cedar, 2008
Recycled cardboard
Lower section: 48.5 x 98 x 96; upper section 18 x 30 x 30
Courtesy of the artist, Seattle.

MARK RUWEDEL (California)

The Hanford Stretch: 100KW and KE Areas (Breaking Camp, Early Morning), 1992–93
Silver print mounted on board with text in pencil
24 x 28 overall
Courtesy of the artist and Gallery Luisotti, Santa Monica.

The Hanford Stretch: East White Bluffs Ferry Site (Steve's Boat/Dead Chinook), 1992-93
Silver print mounted on board with text in pencil
24 x 28 overall
Courtesy of the artist and Gallery Luisotti, Santa Monica.

MATT SELLARS (Washington)

Empty Quarter, 2008
Poplar, paint, and stain
45 x 73 x 93
Courtesy of Platform Gallery, Seattle.

BUSTER SIMPSON (Washington)

DVD of Walla Walla Campanile: Instrument Implement, 2008
Courtesy of the artist, Seattle.
Video production: Star Sutherland

ADAM SORENSON (Oregon)

Banks I, 2009
Oil on linen
40 x 44
Courtesy of James Harris Gallery, Seattle.

Hide Out, 2009
Oil on linen
64 x 47
Courtesy of James Harris Gallery, Seattle

JAMES B. THOMPSON (Oregon)

Furrows, 2006
Intaglio and mixed media on paper
21.25 x 21.25
Collection of the Hallie Ford Museum of Art, Willamette University, Salem, Oregon, Maribeth Collins Art Acquisition Fund, 2006.024.002.

Liminal, 2009
Intaglio and mixed media on paper
21 x 21
Courtesy of the artist, Salem.

Subaqueous, 2009
Intaglio and mixed media on paper
21 x 21
Courtesy of the artist, Salem.

Talus, 2009
Intaglio and mixed media on paper
21 x 21
Courtesy of the artist, Salem.